Hugh Adams

MODERN PAINTING

MAYFLOWER BOOKS
NEW YORK

MODERN PAINTING

OVERLEAF **Noland**: *New Day*, 1967

MAYFLOWER BOOKS, INC.,
575 Lexington Avenue, New York City 10022.

© 1979 by Phaidon Press

All rights reserved under International and Pan
American Copyright Convention.
Published in the United States by Mayflower Books,
Inc., New York City 10022.
Originally published in England by Phaidon Press,
Oxford.

Library of Congress Cataloging in Publication Data

 ADAMS, HUGH.
 Modern painting.

 1. Painting, Modern — 20th Century — History.
 2. Art and Society. I. Title.
 ND195.A34 759.06 78–25566
 ISBN 0–8317–6062–1
 ISBN 0–8317–6063–X pbk.

Filmset in England by SOUTHERN POSITIVES AND NEGATIVES
*(*SPAN*), Lingfield, Surrey*
Manufactured in Spain by HERACLIO FOURNIER SA, *Vitoria.*
First American edition

MOST BOOKS OF THIS SIZE in dealing with so vast a subject as Modern Painting are likely to be idiosyncratic. In the case of this book it is proudly so. At a time when many practising artists are earnestly seeking to increase the size of their audience and relate their work to the concerns of the mass of people, the often dead hand of the art historian is inappropriate. This book is not then an historical guide; but neither is its theme art criticism to which art has been so subjected, that the vital response of the individual spectator has been destroyed. Rather *Modern Painting* is a random survey of what the author finds interesting — even redeeming, at a time when there has been a rejection of the practice of twentieth-century painting. The essay is like a cabinet of curiosities (with some exciting tales of gossip) for that elusive creature, the intelligent layman. There is no 'explanation' of the chosen illustrations, apart from a series of, again idiosyncratic, captions and a few textual references. The viewer is invited to enjoy the game of making the necessary observerations and connections.

It is a trusim, but one worth repeating, that art reflects the epoch in which it was produced. Successive generations of artists have developed aesthetic modes which reflect the spirit of their own age. Our epoch has been apocalyptic: the twentieth century has been characterized by global, rather than national, disasters; yet all of them pale into insignificance when compared with the possibility of the ultimate

Braque: *Still-Life,* 72 × 99cm

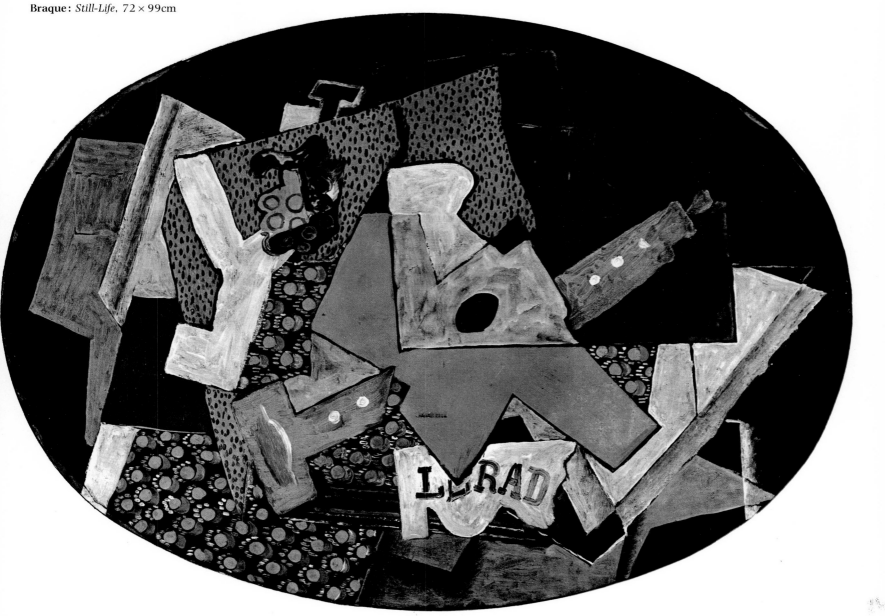

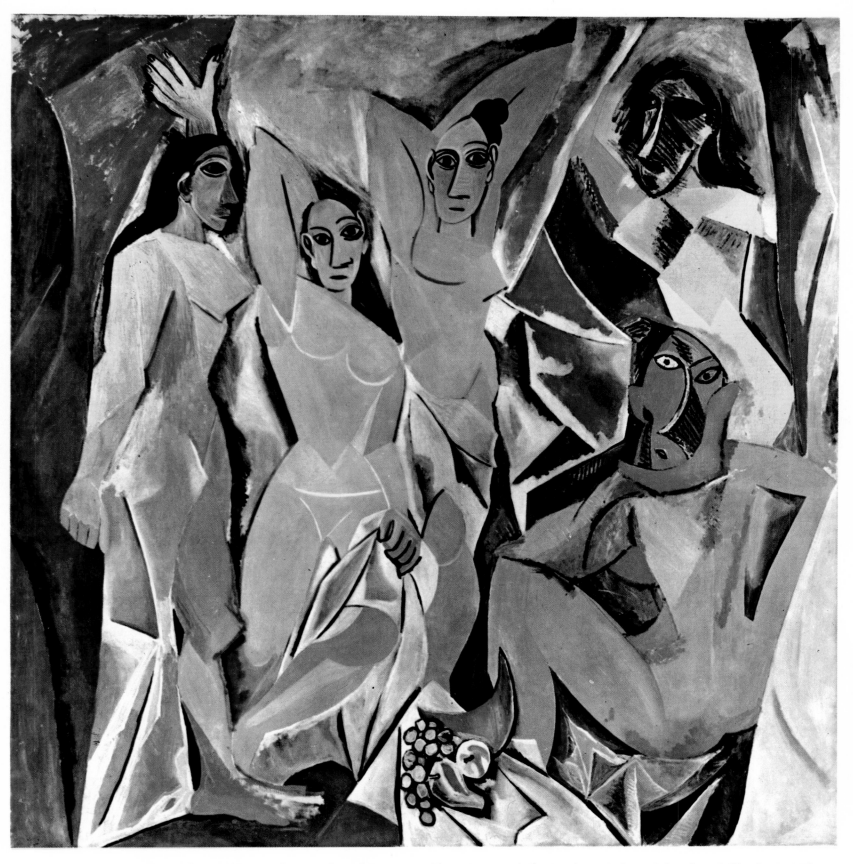

catastrophe resulting in the complete obliteration of human life and all its structures. What sort of art should we expect of such a time, and what can the artist's role possibly be?

During the last twenty years we have, in various ways, accommodated a permanent state of crisis; the angst-ridden period of hyper-awareness was quickly exhausted, and if it finds expression in art nowadays, it is invariably as metaphor only. Anxiety remains, but its mark is made in the temper of the times and is not overtly expressed; its presence is indicated in the periodic vacillation between black despair and the manic optimism of the absurd. The hysterical consumer hedonism of the sixties was an instance of the latter; the former being exemplified by today's gnawingly puritanical need to justify art in social terms – to make it 'relevant'.

Clearly, present austerities are a reaction against former expansiveness. The process illustrates the 'swings and roundabouts' syndrome which often seems to indicate a biological need for change, almost for its own sake. Disaffection with the lavish devil-may-care mood of the sixties

Picasso: *Les Demoiselles d'Avignon*, 240 × 230cm, 1907

The title of the painting, like that of most of his paintings, is not Picasso's own. It was given later and thus yields no clue to the meaning of the work. Early studies for it (there are at least seventeen of them) show that it began as an allegorical composition. Professor Hoffman suggests that initially it was a version of 'The Judgement of Paris' or a treatment of 'the antithesis between man and woman, or the duality between vitality and death'. Early versions relate strongly to Cézanne's *Bathers* and *Three Bathers*, and as Cézanne died in 1906 it is possible that Picasso intended it as an homage to him. Without doubt, the scene is a brothel; Picasso originally planned two sailor figures, one major, the other minor, and five naked women. Nothing remains of these but three ambiguous figures who either are masked, or may be the beginnings of a reworking of the picture in a further development of the expression of space and volume. The right hand standing figure shows Picasso's latest experiment with cross-hatched lines and geometrical cut-outs and is reminiscent of African sculpture. There is evidence of a debt to Egyptian pictorial conventions too, in the figure on the extreme left. Colour is arbitrary, putting us in mind of Picasso's earlier Rose Period, except where he has attempted hatching and relief and these areas signal the advent of Cubism. The picture is a crucial one in the history of twentieth-century art. It was the focus of Picasso's spatial and perspectival experiments to date, marking his relinquishment of classical perspective. It inaugurated a revolution in art at precisely the time when scientists also realized the necessity for reconstructing their theories and models for the representation of the physical universe. Despite its later consecration, the painting earned Picasso the scorn of his friends and dealers. It was not bought until 1920 and not publicly shown until 1937.

Pages 8–9. **Matisse:** *The Dance*, 261 × 390cm, 1909–10

Matisse was the leading light of Fauvism. Its beginnings can be detected in his work as early as 1898, when his work was influenced by the unbroken surfaces of Gauguin, the colour of Signac and Seurat and the impetuous spontaneity of van Gogh. He wrote: 'The art of composition consists in being able to arrange the different elements which the painter has at his disposal to express feelings in a decorative manner . . . A work of art entails a harmony of the whole; any superfluous detail would thus take the place of an essential detail in the mind of the spectator.' *The Dance* is an illustration of how far Matisse went in paring down the elements when composing a picture: he subdued any tendency to illustration or decoration, simplified figures and severely confined his use of colour. In 1910 Matisse saw an exhibition of Eastern art which confirmed his interest in the development of flat patterns, arabesques and brilliant pure colours which was to characterize his work for the remainder of his life.

has resulted in the development of the seventies' 'monochrome-minimalist' aesthetic. Artists frequently feel that they have to justify what they do in terms that are not artistic and that art is essentially a dilettante pastime which has to be harnessed to another intellectual activity before it can merit serious attention. And this is not surprising when most people regard art as an irrelevance or, at best, an occasional diversion, on a par with a football game or a shopping expedition. An obvious result of the new puritanism is the preponderance of ethical over aesthetic considerations. In spirit, the seventies are like the Victorian heyday, with art in the service of morality; the differences are that we lack both the self-confidence of High Victorian artists and the crowds who flocked to see their paintings. For the most part the contemporary artist emulates his nineteenth-century counter-

Rouault: *Aunt Sallies*, 74·9 × 105·4cm, 1907

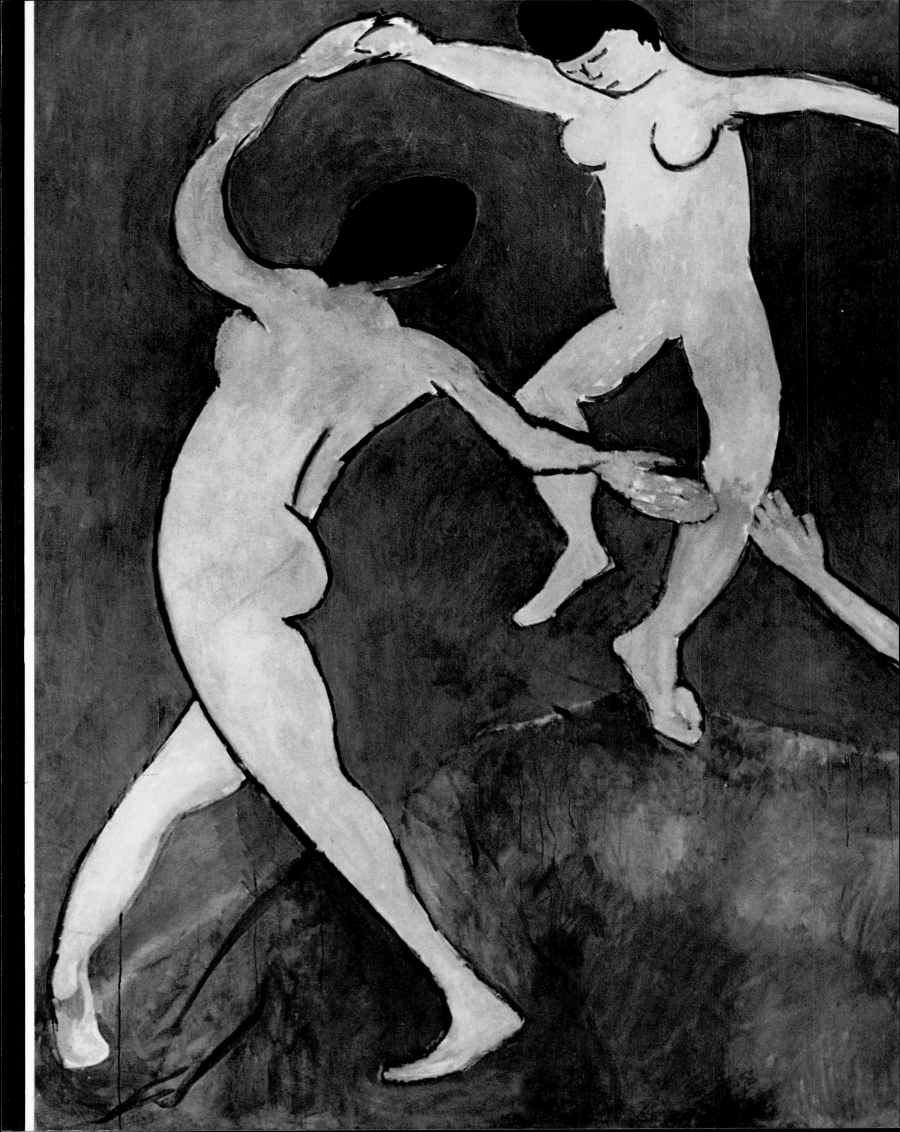

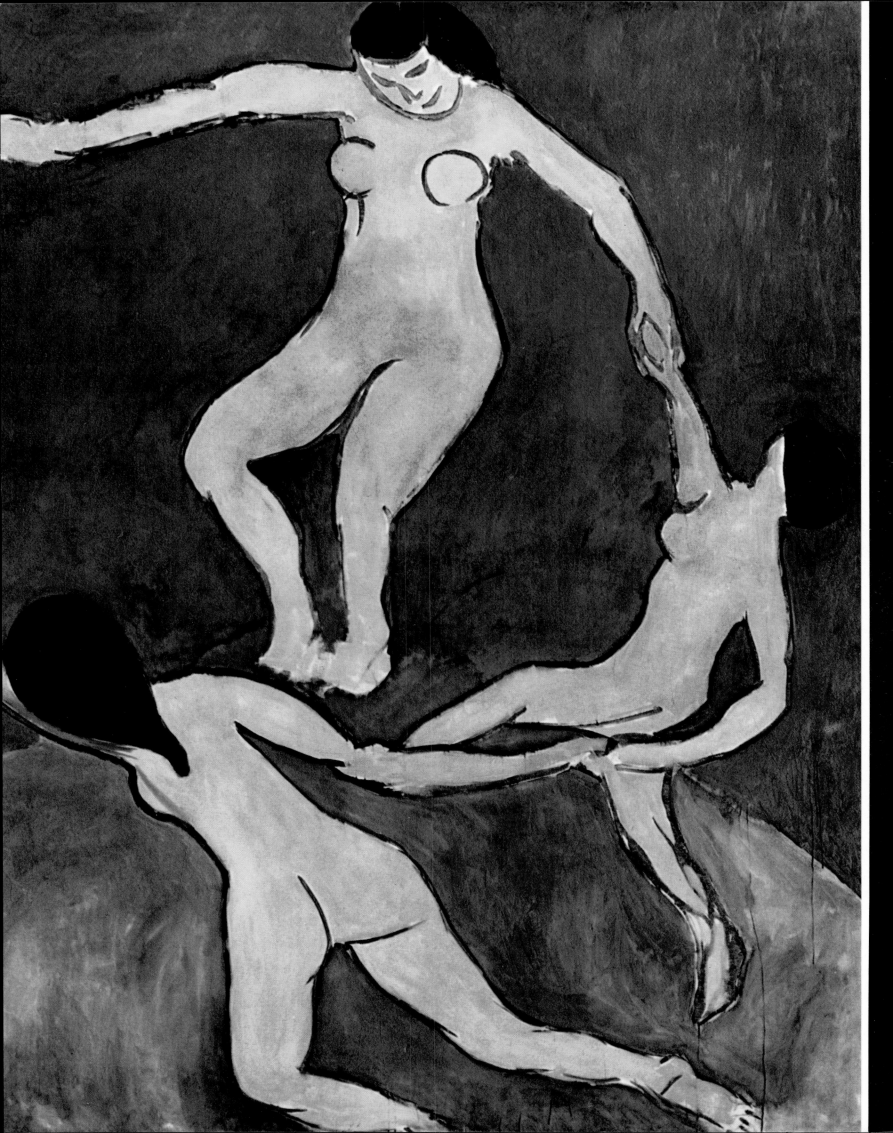

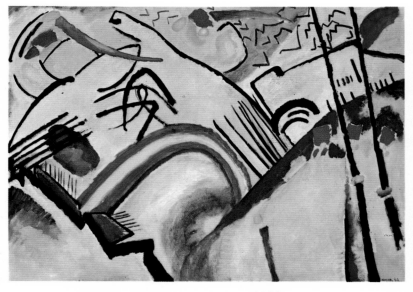

Kandinsky: *Battle*, 94·6 × 130·2cm, 1910

part, and he rejects the subversive role, which intermediate artists have embraced, in favour of bourgeois order. Conceivably a latter-day parallel to fin-de-siècle decadence is to come.

In the classical era, it was acknowledged that artists provided an ordered vision of the world. But subsequently the artist, while upsetting current orthodoxies and institutions, has failed to replace them with new models and new truths. Nowadays the artist's position in society has altered to the extent that he has surrendered his former prerogatives — those of introducing change and new ways of refining our perception of the world; presenting insights into the art of the past; establishing means of coping with the present, and devising new orientations for the future. The artist has lost his self-assurance and conviction of the rightness of his purpose, so much so that he has taken refuge in the production

Nolde: *Christ among the Children*, 87 × 106cm, 1910

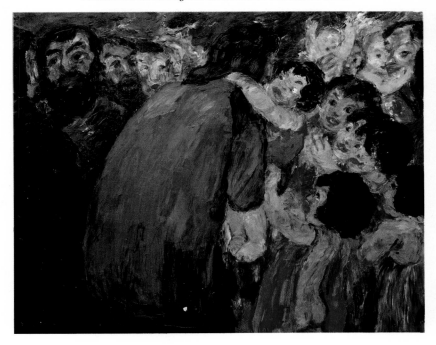

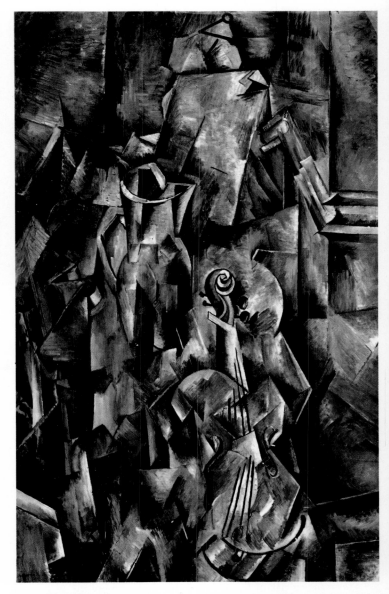

Braque: *Violin and Pitcher*, 117 × 73·5cm, 1910

Braque anticipated Picasso in exploiting the lesson of Cézanne; by 1909 he had modified the colour investigations of his Fauvism by introducing the basic geometrical forms of Cubism and reducing his colour range to greys and browns. This emphasized the fact that *form* had become his first preoccupation. The Cubists went further than Cézanne, for while he evolved a visual system from nature which he modified and applied to its reinterpretation, they treated the shapes which they evolved as autonomous — hence Picasso's intellectual game. Eventually these became elements to be formally manipulated on the picture surface in an absence of conventional perspective and atmosphere. Picasso explained Cubism by saying that it worked in a way that was analogous to putting a chair through a heavy press. This was an oversimplification for it ignored the selection, analysis and subsequent manipulation involved in the creation of a rhythmic order such as is found in this painting.

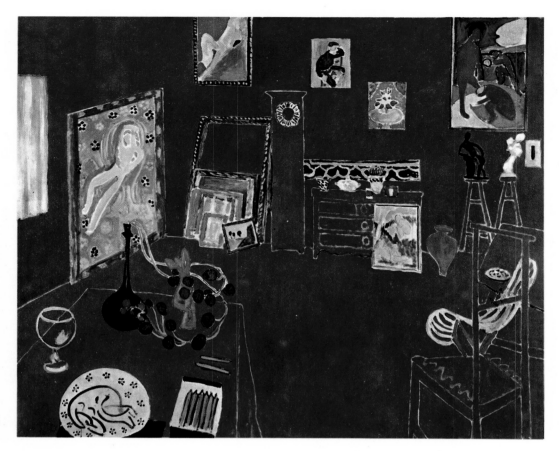

Matisse: *The Red Studio*, 177·5
× 215cm, 1911

of what is esoteric and arcane. He is often under the mis-apprehension that by so doing he is relating more effectively to his audience, but whose true nature he imperfectly under-stands. What is most absent now is the simplicity and humour which has characterized art so far this century. This absence has further diminished the artist's already small audience to the extent that it has all but vanished. The crowds who flock to the galleries eschew the 'serious' con-temporary art of the new puritanism, in favour of history shows and vulgar, media-inflated raree extravaganzas.

Artists and art-commentators are currently agonizing about this lack of an audience — either in an epic of cynicism or one of self-delusion. The 'Art for Whom?' debate, with its harvest of theme exhibitions and simultaneous publications has become a new cottage industry. Yet the 'problem' is not a new one. Picasso, asked in 1946 if there was a divorce between the artist and the public, thought there was, but felt that it was momentary:

> Neither the artist nor the public is to blame for that. The public doesn't understand modern art . . . the reason is that nothing has been taught about painting. They have been taught to read and to write, to draw and to sing, but it never occurred to teach people how to look at a paint-ing . . . They are completely ignorant of the plastic values.

This problem has been the basis of art critical discussion for as long as there hav been art critics. It is merely the ritual, masturbatory dialogue about the relationship between 'art' and 'life'. Any difficulty in appreciating this is compounded by an assertion on the part of many critics that the activities of painting and sculpture are beneath the attention of good artists, who have anyway significantly failed to exploit them

as methods of 'problem' solving. Behind the assertion is the implication that the 'problems' are socio-political, and that artists should desist from purely speculative, quasi-philo-sophical and 'selfish' art-about-art practices, and set about addressing their talents to contemporary societal problems. It ignores the fact that even good contemporary painting and sculpture are of a lower standard than the art of the first half of the present century, for they have lost the vigour they

Pages 12–13. **Boccioni:** *The City Rises,* 196 × 296cm, 1910

Futurism is typical of many twentieth-century art rebellions. It started in Milan in 1910 and was fiercely critical of contemporary culture. Like Vorticism in England it sought to establish a machine aesthetic and to rid itself of the dead hand of the past. Ironically, it had been anticipated by Oscar Wilde in his statement that 'the line of beauty and the line of strength are one'. Unlike many other avant garde movements Futurism was not anti-art; Futurists simply wished to dynamize art. Marinetti in his Futurist manifesto wrote that 'a roaring automobile . . . is more beautiful than the Winged Victory of Samothrace', and he attacked moribund cultural institutions and bourgeois morality in general. The artists attempted to bring the intense modern sensations of life into their work, and they created paintings of tremendous kinetic vitality. Futurism with its emphasis on manifestoes, demon-strations and mixed media events, not only served as a model for later revolutionary movements such as Dada, Constructivism and Surrealism, but also as a cynosure for the younger generation of artists of today.

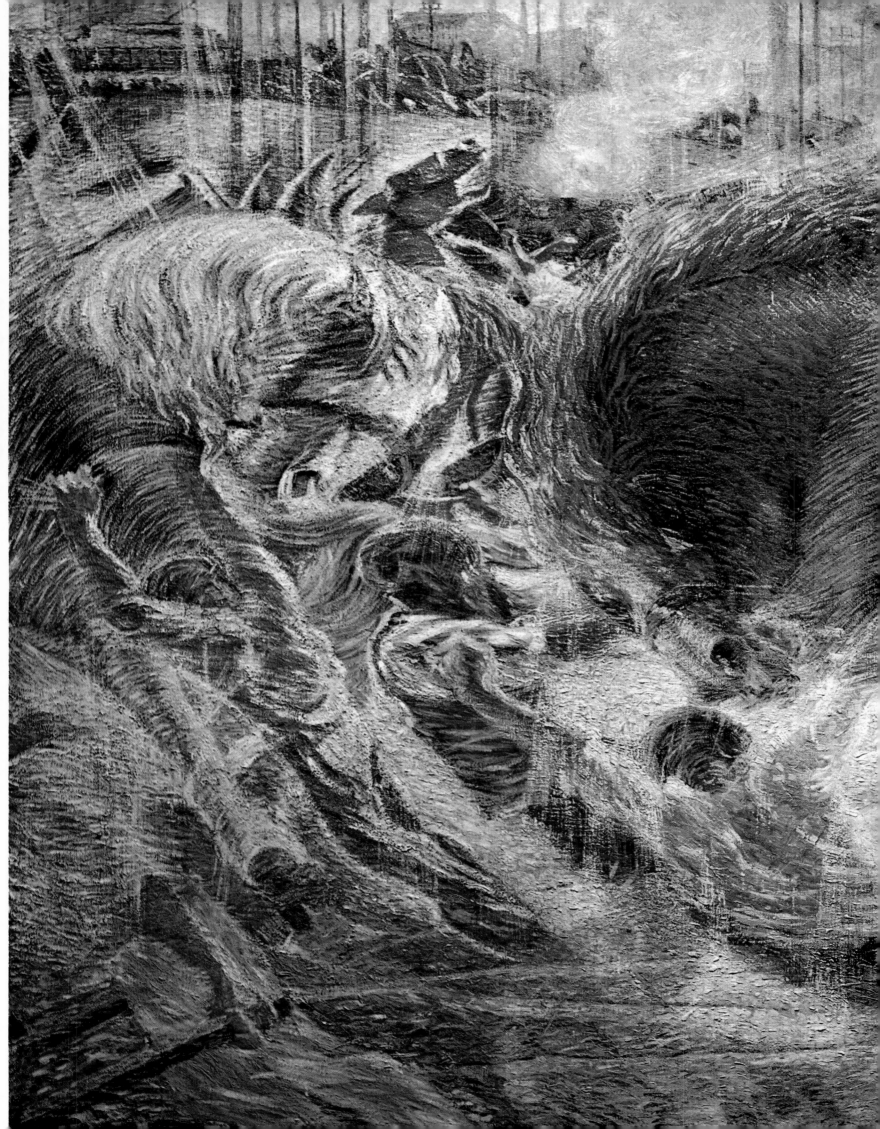

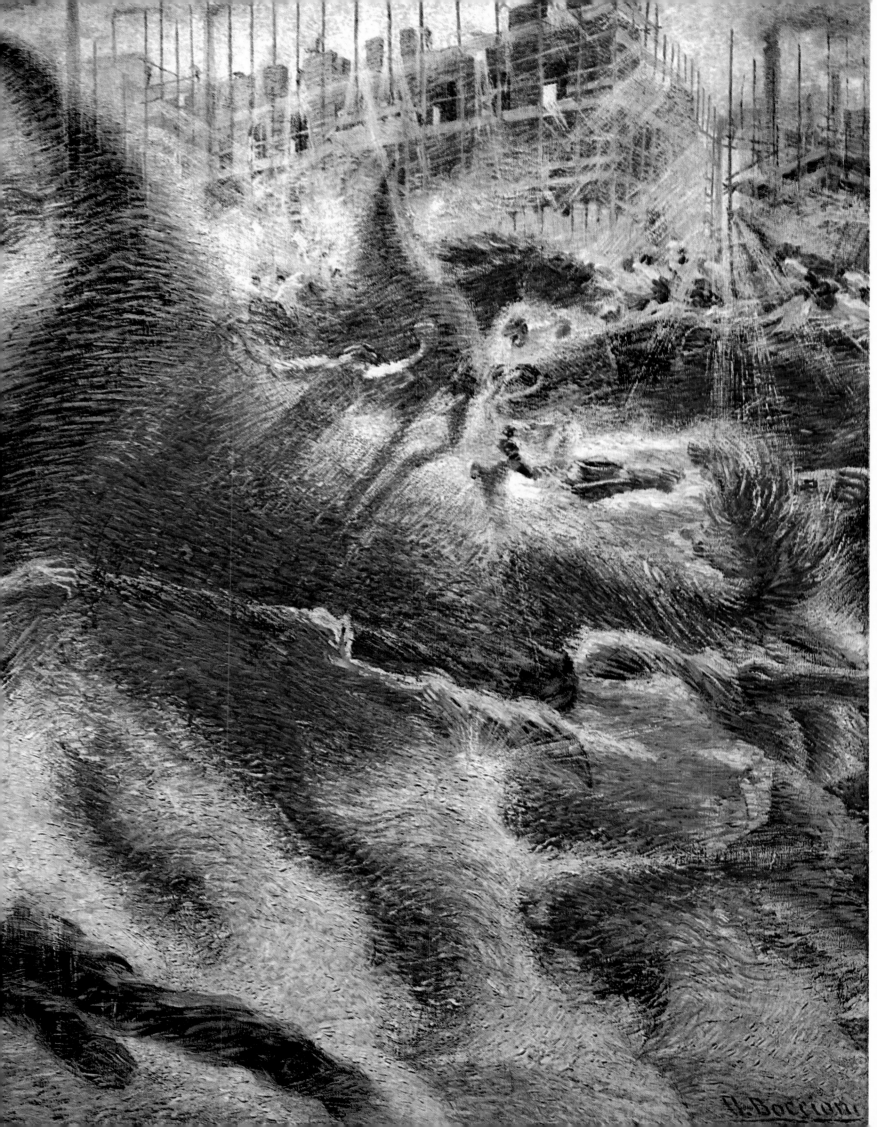

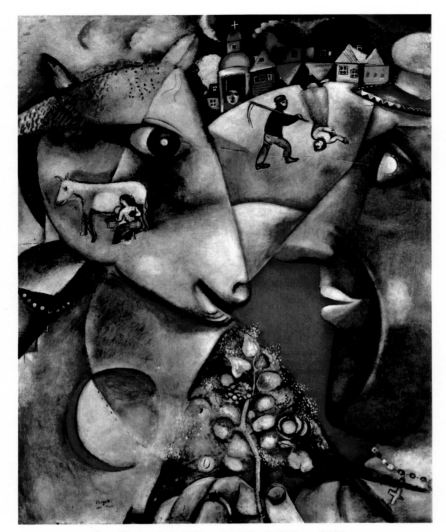

Chagall: *I and the Village*, 187·5 × 147·5cm, 1911

trinsically flawed is to criticize one game as being imperfect because it is not conducted in accordance with the rules of another.

Obviously, there is a certain irony in presenting a book about modern painting at the very time that a break in the tradition seems to have occurred. The enormous frustration at the limitations of painting which has been building up throughout the century has reached its zenith at the time that real alternatives have emerged. Although the significance of Maurice Denis' injunction to remember that a painting 'before being a battle horse, a nude woman, or some anecdote – is essentially a plane surface covered with colours, assembled in a certain order' (*Definition of Neotraditionalism*, 1890) did not last much after 1900, it was a further sixty years before the importance of the plane surface was seriously challenged. Even today, the vast majority of people believe that art is concerned with the choice disposition of appropriate, and therefore pleasing, forms. During the modern period they have come to accept that art is constituted either by geometrical forms having their roots in industrial design or (preferably ?) by organic forms, whose origins lie in nature. Before the 1940s this audience expected harmony in art, just as now it is prepared for dissonance and disturbance. But even quite informed people look for these things *within* painting and sculpture. They *know* what art is.

Notwithstanding the art of the fur-covered teacup, the urinal, the ready-made, collage and assemblage which date from the first part of the century, it was not until the early-sixties that artists exploited alternatives to conventional painting and sculpture prolifically. The consequence was that for the subsequent ten years not many important, new ideas in art have been expressed in the two media. Land Art, Project Art, Body Art, Art Povera, Performance, Concept Art, Post-Object Art, Post-Minimal Art, all emerged as

Braque: *Man with a Guitar*, 115 × 77·5cm, 1911

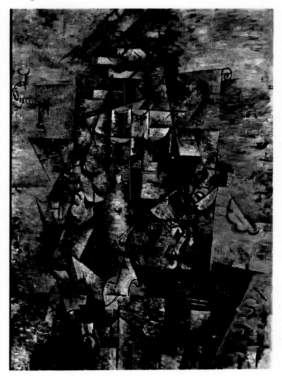

possessed then, and, for the expression of serious ideas, they have been superseded by new media. That this is simply the result of time and the fact that the new media are more efficient, fluid, immediately responsive, and more easily *displayed*, has been overlooked. Painting and sculpture may have become redundant, for reasons of technological development. But to persist in seeking effective late twentieth-century metaphors in what may fairly be regarded as *passé* craft activities is as absurd as to insist on playing modern music on sixteenth-century instruments.

The attempt to make art relevant to the people, or to enable people to exploit the potential of art, is a misguided one. It is simply a new version of the philanthropic-paternalistic attitude of 'taking of art to the people' – equivalent, as an example of misplaced proselytization, to the Victorian lady of the manor wanting to distribute improving tracts to the peasantry on her estate. The social class, if not the prejudices, of the latterday donors are the same. Also, while conventional modern drama, literature and music can be taken out of their accustomed venues, conservative art-painting and sculpture cannot; they need the plinth, the wall, the frame and the gallery. It is absurd to criticize painting for its failure to operate effectively within or outside the gallery system. To suggest that as practices they are in-

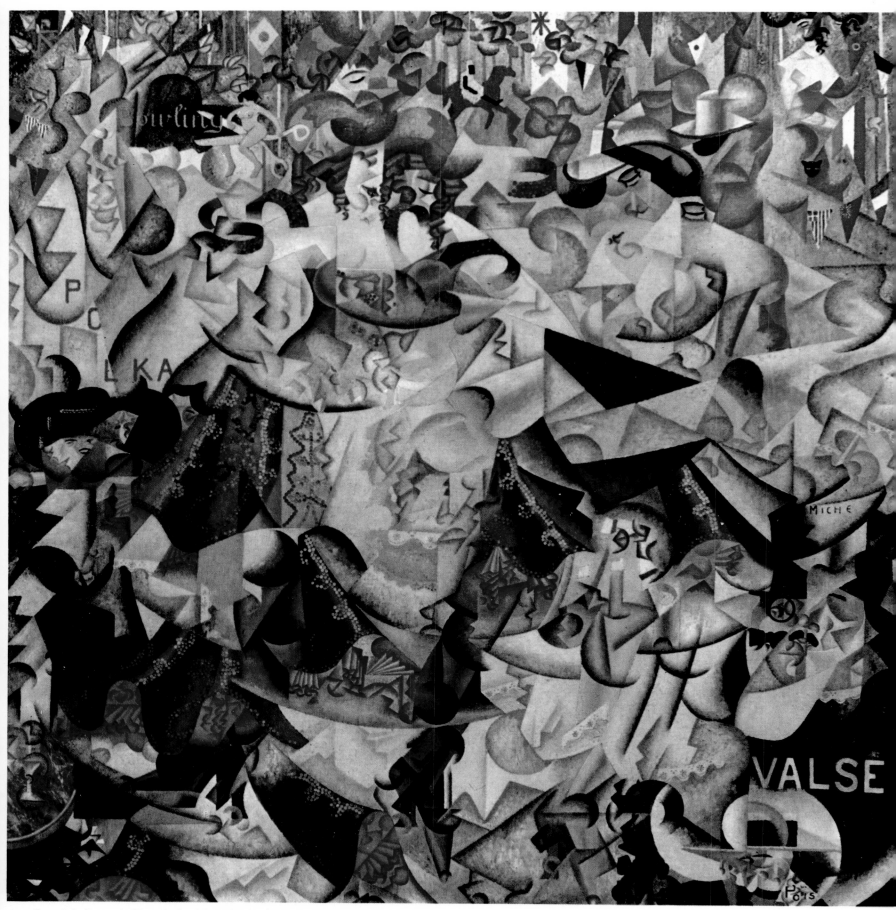

Severini: *Dynamic Hieroglyph of the Tabarin Ball,* 157·5 × 154cm, 1912

vigorous alternatives to traditional modes. Even photography, of which the full potential has yet to be realized by artists, is now being exploited in such a way as to justify an earlier prediction that it would become the dominant mode of expression for artists for many years.

Yet, if painting is a thing of the past, as was asserted as long ago as the 1830s — De la Roche is credited with the statement 'From today painting is dead', at the advent of the daguerrotype in 1839 — then it is a long time dying. Although a later prediction that art would not necessarily consist of a

15

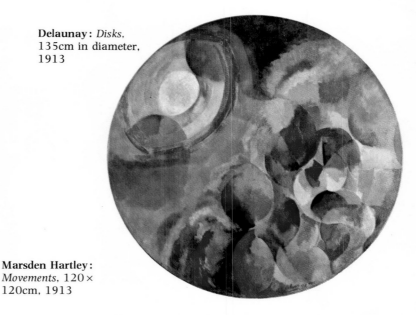

Delaunay: *Disks,* 135cm in diameter, 1913

Marsden Hartley: *Movements,* 120 × 120cm, 1913

material product has been realized, it is far from being a universal truth. The majority of artists are still concerned with the manipulation of form — be it two or three dimensional. The avoidance of painting and sculpture by many mainstream artists ought not to be interpreted as an attack on these activities *per se* — or as an irrevocable abandonment of them. But many of their practitioners have construed it as such and reacted to the emergence of an 'antipainting' establishment of critics. There has been a savage rearguard action by painters and their supporters, especially by those figurative painters who became prominent in the

early sixties, which I deal with below. However, even to abandon the practices of painting and sculpture does not necessarily mean a complete rejection of their traditions. Many of those artists indulging in the most outré versions of Body or Conceptual Art, and who may be most critical of what they see as the 'bourgeois' state of art, make constant, if ironic, references to the *Beaux Arts* in their work.

Painting and the new modes are not mutually exclusive: many of the best practitioners in both areas express their ideas in a wide range of ways. For many the relinquishment of painting, whether temporary or permanent, is part of the

Chagall: *The Cattle Merchant,* 97 × 200·5cm, 1912

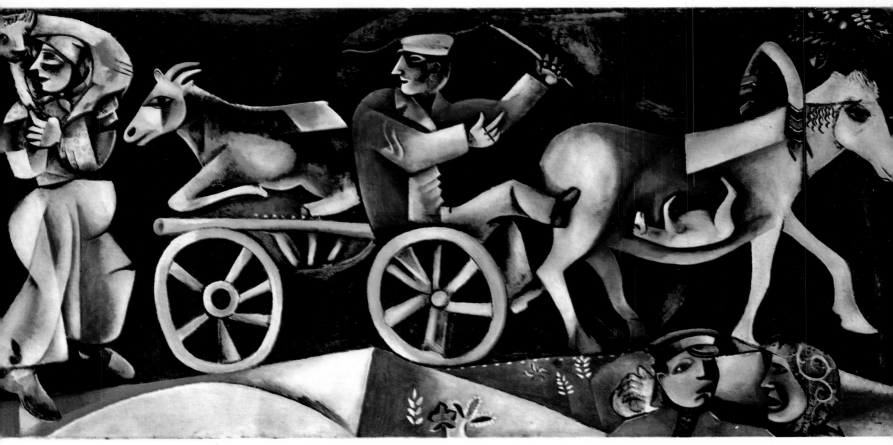

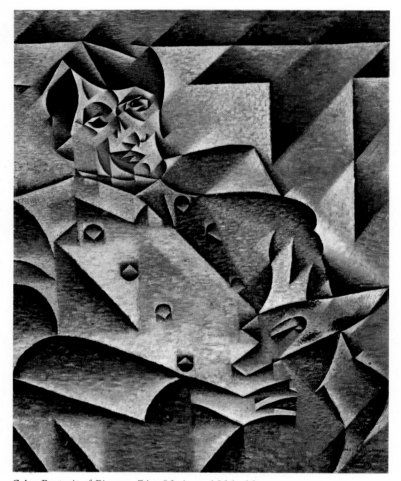

Gris: *Portrait of Picasso*, 74 × 93·4cm, 1911–12

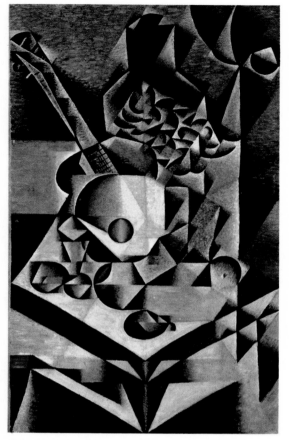

Gris: *Guitar and Flowers*, 110 × 67·5cm, 1912

rejection of the traditional format of a painting. The form of an art work is the result of the artist's decision about how to relate art to reality. Prior to the twentieth century, there was general agreement about what a painting was. It was considered either a plane surface covered with colours, a faithful attempt to represent the appearance of objects in the natural world, or a piece of trompe l'oeil, an effort to confuse the spectator into thinking that he was looking at real objects — rather than just their representation. When the artist abandoned attempts at verisimilitude and illusionism there was no longer the need for a square or rectangular canvas, corresponding to a stage, or a window into another world.

Yet a large scale move away from that kind of format took a century to happen. Increasingly painting ceased to be the dominant means of expression during the century, because of frustration at its limitations. Most of the limitations concerned time, for traditionally paintings represented 'a frozen moment'. In the 1880s E. J. Marey attempted to convey motion in one image by taking successive photographs on a single plate of a man in movement. The results show a startling similarity to the later works of some of the Italian Futurists such as Giacomo Balla's *Dog on a Leash*. Duchamp's *Nude Descending a Staircase* is another example of the attempt to convey motion on a single canvas. The Futurists saw their desire to create a machine aesthetic as the means of destroying the cultural stagnation of Italy. Their paintings like Boccioni's *The City Rises* or Severini's *Dynamic Hieroglyph of the Tabarin Ball* are full of dynamic movement, but they

remain pictures on a single plane. Similarly, Boccioni's sculpture, *Unique Forms of Continuity in Space*, albeit three dimensional, is limited in its depiction of movement. The Cubists imported many mechanical shapes into their art in their attempts to give an illusion of three dimensional form. Leger, above all, seems to have resented the limitations of the picture frame. His *Village in the Forest* seems to beg to be liberated from it. The other artists, with the exception of

Bomberg: *Mud Bath*, 152·4 × 224·2cm, 1912–13

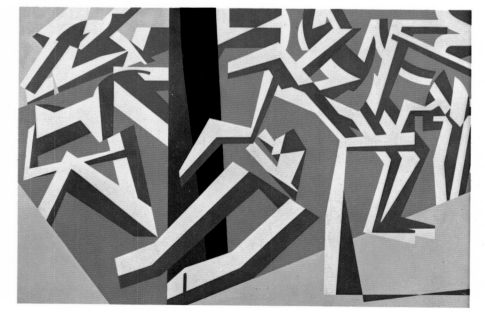

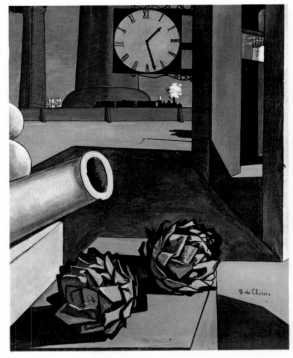

de Chirico: *The Philosopher's Conquest*, 126 × 110·5, 1914

Kokoschka: *Bride of the Wind*, 181 × 221cm, 1914

Kokoschka was advancing his ideas about a new expressive art in Vienna, rebelling against the dominance of Jugenstil, at the same time (1905–6) that Expressionism was developing independently in Germany with the formation of Die Brücke group (which included Kirchner, Schmidt-Rottluff, Heckel) in Dresden and Der Blaue Reiter group (including Marc, Kandinsky, and later Klee) in Munich. The latter were closest in spirit to the Fauves (they also admired the work of Munch, Gauguin and Van Gogh) who, seemingly in response to the same modernist impulse, began work in France around that time. Kokoschka's work differs significantly — no technical tours de force until late in his career — by being austere, restless, highly allegorical and mystical. Thomas Mann described it as 'civilized magic'. His expressions of a personal anguish at a time of cruelty and flux in Central Europe took on a shimmering, hallucinatory quality. This painting (of himself and Alma Mahler) is highly individualistic and really resists categorization; there is baroque self-possession, great strength and visionary power. In his work paint is often scraped sparingly on the canvas and then subjected to restless scratchings. These succeed in enhancing the feeling of energy which courses through it. This technique was particularly effective in his more conventional portraits, where his attenuations of the figure and nervous treatment of the hands come close to caricature.

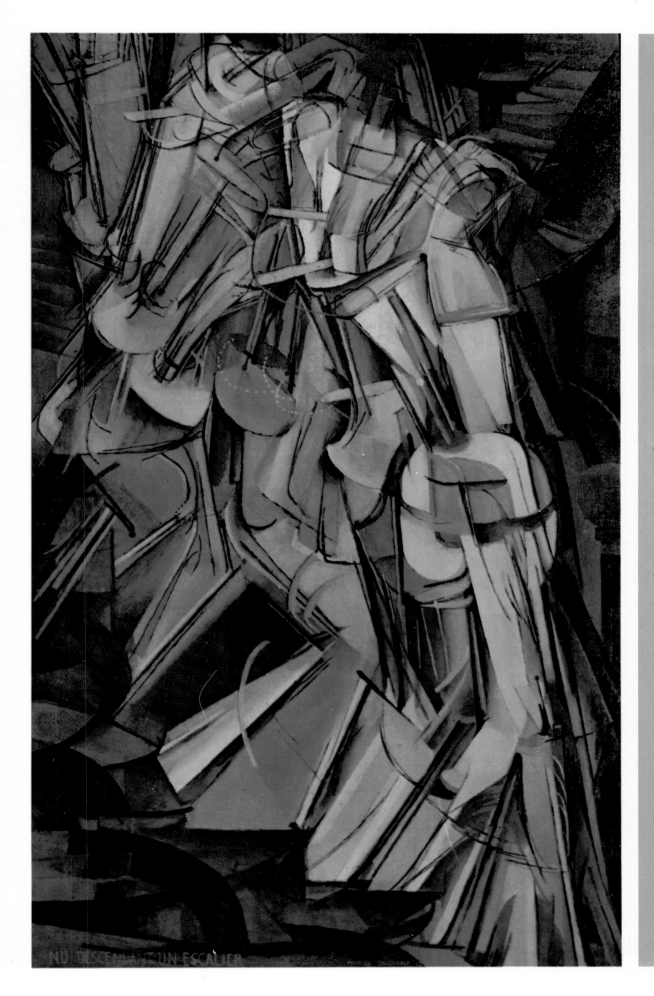

Marcel Duchamp: *Nude Descending*, 147·4 × 88·9cm, 1912

Duchamp dominates modern art like a colossus; for the present, he is the most influential figure, yet he is arguably the most misunderstood artist of our epoch — if only because he himself fostered ambiguity about his own art and life-style. He was not 'anti-art', but an artist troubled by the role of art in the mechanical age. Duchamp questioned the very basis of artistic activity, and his attitude to the machine as a substitute for hand craftsmanship was profoundly ambivalent. His singular contribution to Dadaism was the development of what Alfred Barr has called 'organic or biomorphic' abstraction through his alteration of mechanical, rather than natural, forms. Only Picabia approaches him in this. His investment of quasi-functional mechanical devices with human foibles and characteristics resulted in works that continue to exert a profound influence on the younger generation of artists. His rigorous recording of the recording of the creative process and his presentation of working drawings, plans and notes in his 'boxes' anticipated the drive both to document and to expose the creative process, an idea which has gained currency in the 1970s. His animation of Analytical Cubist forms and the creation of a machine-monster parallels closely the Futurist Boccioni's sculpture, *Unique Forms of Continuity in Space* of the same year. *Nude Descending* was the major contributor to the row surrounding the Armory Show in New York, 1913, when Duchamp showed this painting as the first public demonstration of his later interest in the development of machine-mythologies. Works like this one and *Bride Stripped Bare by her Batchelors* (the *'Large Glass'*), said to be a rape scene using machines as metaphor — but interpretations are legion — are of seminal importance in the history of twentieth-century art. This is the first successful attempt in painting to realize movement and depict the passing of time on a static flat canvas.

Braque and Picasso who made cardboard constructions – confined their experiments to canvas. Duchamp, the youngest of the Cubists, at the beginning of his career quickly abandoned paint on canvas in his obsession with movement and machines.

The first major rebellion against the framed painting was by the Dadaists. Duchamp's *Fountain*, of 1917, a urinal (signed R. Mutt), was submitted to an exhibition of the American Society of Independent Artists, who refused to accept its designation as a 'ready made' art work. The *Fountain* together with other of his works like *Bicycle Wheel* of 1913, *Bottle Rack* and *Snow Shovel* of 1915, were called 'Readymades'. He justified them in 1961: 'A point which I want very much to establish is that the choice of these "Readymades" was never dictated by aesthetic delectation. The choice was based on a reaction of visual indifference with at the same time a total absence of good or bad taste ... in fact a complete anaesthesia.' By this gesture Duchamp repudiated traditional aesthetic canons and artistic conventions. For him the attraction of the 'Readymades' was their

Léger: *Village in the Forest,* 130 × 97cm, 1914

Léger admired the brashness of the emerging mass society; eschewing beaux arts themes, he chose to treat subjects with which the mass of people would more readily identify. His intention was to create a democratic art. Like both the Cubists and the Futurists, Léger too claimed that his art was one of realism though he thought that 'the *realistic* value of a work is independent of all imitative quality.' He was akin to the Futurists in his desire to create an art that was a concrete expression of the mechanical age – in 1924 he made a film in which he compared the mechanical movements of dancers with manufactured objects – but he rejected their literary and romantic aspects in favour of a purer and more objective abstraction. He broke with the Cubists although his work, according to Cézanne's dictum of reworking nature in terms of the sphere, the cone and the cylinder, is often purer than theirs. In 1913 he began a series of paintings in which all representational elements were eliminated, but which still suggested machine-made forms. His work is simple, and while avoiding the trap of Social Realism he produced an accessible art. Léger said: 'The modern conception of art is thus not a passing abstraction valid for a few initiates only; it is the total expression of a new generation whose condition it shares and whose aspirations it answers.'

Kandinsky: *Composition for a Mural Painting,* 160 × 77·5cm, 1914

de Chirico: *Enigma of the Oracle,* 138 × 95·5cm, 1914

De Chirico's work is conditioned by the influence of two philosophers: Nietzsche and Schopenhauer. The latter believed that to have original and extraordinary ideas one had to develop the faculty of isolating oneself completely from the world for brief periods so that commonplace events and scenes became unfamiliar, and thereby revealed their true essence. Like Nietzsche, Schopenhauer considered men and objects chimerical; he felt that apparent reality was no more than illusory, and beneath it lay another concealed reality. De Chirico created his own melancholy Neo-Classical dream world with vast columned squares empty, save for the ambiguous presence of disjointed out-of-scale and out-of-place objects, whose appearances, when seen together, set up whole fields of fresh meanings and resonances. Whereas the Cubists sought new ways to depict a reality they were confident about, de Chirico explored dream states in order to discover where reality lay. Although his career spans a long period, the work for which he is famous was done at the time of the 1914–18 war.

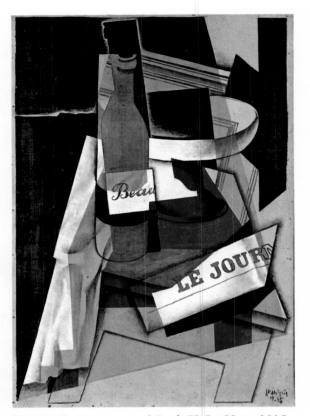

Gris: *Bottle, Newspaper and Bowl,* 72·5 × 50cm, 1915

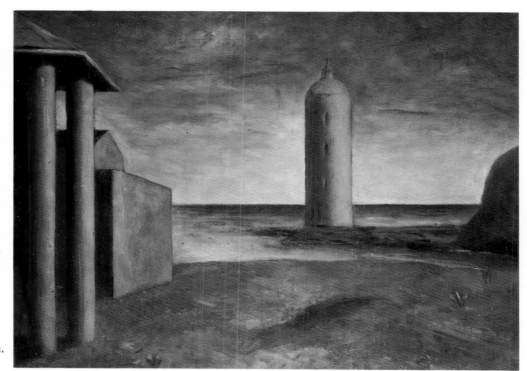

Carra: *The Lighthouse*, 70·5 × 90cm, 1916

lack of uniqueness, and the fact that they resisted take-over by amoral art institutions.

Vladimir Tatlin, the Russian Constructivist, made his first *Painting Relief* in 1913. Four years later Rodchenko, Yakulov and he decorated the Café Pictoresque in Moscow with sculptures which were linked to painted reliefs on the walls and ceiling. When the Revolution came their energies were harnessed in its service. As Malevitch said: 'Cubism and Futurism were the revolutionary forms in art foreshadowing the revolution in economical and political life of 1917.' Con-

ventional easel painting was of little use in such a situation. Revolutionary propaganda needed a greater scale; 'agit-boats' and 'agitation-instruction' trains, their sides garishly painted, bore the message of revolution. Tatlin advocated a 'union of purely artistic forms (painting, sculpture and architecture) for a utilitarian purpose'. Less constructive, the Dadaists too rebelled against the confinement of the frame, which would not have been consistent with their crusade for the irrational and confused.

Almost anything was grist to the Dada mill — provided it

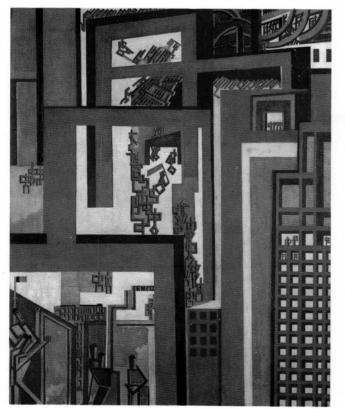

Lewis: *The Crowd*, 200 × 153cm, c.1915

Wyndham Lewis was the prime mover and apologist for the English Vorticist group, founded in 1914. Its name was coined by Ezra Pound, and deriving its aesthetic from Futurism and Cubism, it pioneered abstract art in England. Lewis was a founder member of the Camden Town Group, the only 'progressive' group of artists then in existence. In common with many artists of his generation, he looked to the Continent for inspiration and became an apostle of revolutionary modernism. After founding the Rebel Art Centre in 1914 he edited the first number of *BLAST* — 'BLAST first (from politeness) ENGLAND' — an iconoclastic publication par excellence. 'We only want the world to live, and to feel its crude energy flowing through us . . . Blast sets out to be an avenue for all those vivid and violent ideas that could reach the public in no other way.' Lewis was a successful polemicist rather than a great artist. Of the work that created his reputation there was never much. His importance is as a revolutionary figure who succeeded in creating a communal lust for explosive renewal and change. His early work was strongly abstract in a Cubist manner, and his drawings invariably mechanistic. After the 1914–18 war his work lost its impetus: his portraits of Edith Sitwell and T. S. Eliot, although dramatic, indicate the changed mood.

23

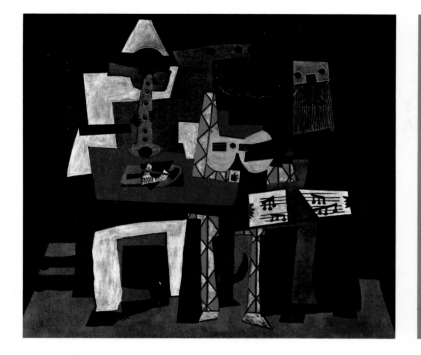

Picasso: *The Three Musicians*, 190·5 × 217·5cm, 1921

This painting represents the summation of Picasso's work to date. It contains many elements and references to his own earlier paintings and to those of his contemporaries (he claimed that no one could make Cubism alone, that it was the work of thousands). The painting is the masterpiece of Synthetic Cubism and a far cry from earlier Cubist attempts to present a new visual reality. It is the absolute antithesis of the visual dynamism which Léger earlier established in his work. This is a tightly structured, hieratic, formal composition which even its carnival theme and strong leavening of humour (there are a number of visual puns) does not save from solemnity. Picasso said: 'Many think that Cubism is an art of transition, an experiment which is to bring ulterior results. Those who think that way have not understood it. Cubism is neither a seed nor a foetus, but an art dealing primarily with forms, and when a form is realized it is there to live its own life.'

Malevitch: *Suprematist Composition: White on White,* 1918

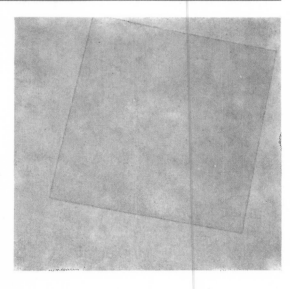

Mondrian:
Diagonal Composition,
60·1 × 60·1cm, 1921

was nothing which one might associate with conventional art. Kurt Schwitter's junk constructs, collages, such as *Aerated VIII*, mertz-walls and, later, complete environments, hardly strike us now as revolutionary, or even remarkable, but they, too, provided a foundation for subsequent developments and were precedents for Jasper Johns and Robert Rauschenberg. Both began including junk in their canvases, and later extending the canvases into the room as in Johns' *Studio* and Rauschenberg's *First Landing Jump*, in revulsion against the pristine austerities of Colour Field painting and Abstract Expressionism, and in an attempt to bridge what

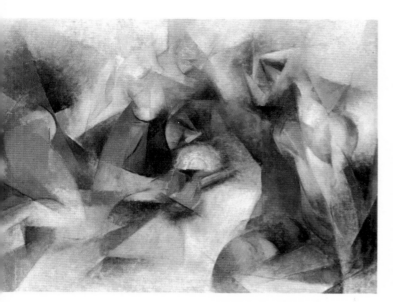

Macdonald Wright: *Oriental Synchromy in Blue-Green*, 91·4 × 127cm, 1918

Léger: *Bowl of Pears*, 79 × 98cm, 1923

Rauschenberg characterized as the 'gap between art and life'. Robert Rosenblum wrote: 'Every artist after 1960 who challenged the restrictions of painting and sculpture and believed that all life was open to art is indebted to Robert Rauschenberg.'

Both Rauschenberg and Johns, in their turn, contributed to the state of almost unlimited 'permissiveness' in art. In the late fifties and early sixties it became impossible to distinguish between the art work and the spectator's space. The framed canvas which had been completely annihilated was replaced by environments totally enveloping the spectator, who was required to participate in their animation. Other artists abandoned the canvas so that they could take art into the streets to make it more accessible to the public. Generally, the emphasis was on spectator participation. Now, things are in a state of considerable confusion, with no single mode of expression having replaced paintings as works of art. Similarly, there is confusion over the role of the creator, who might take on any one or an amalgam of traditional roles, such as those of actor, spectator, animator, collaborator. One thing is certain — he will be ill-prepared for it. Just as the educational system generally fails to teach people to understand possibilities of exploiting art, the art educational

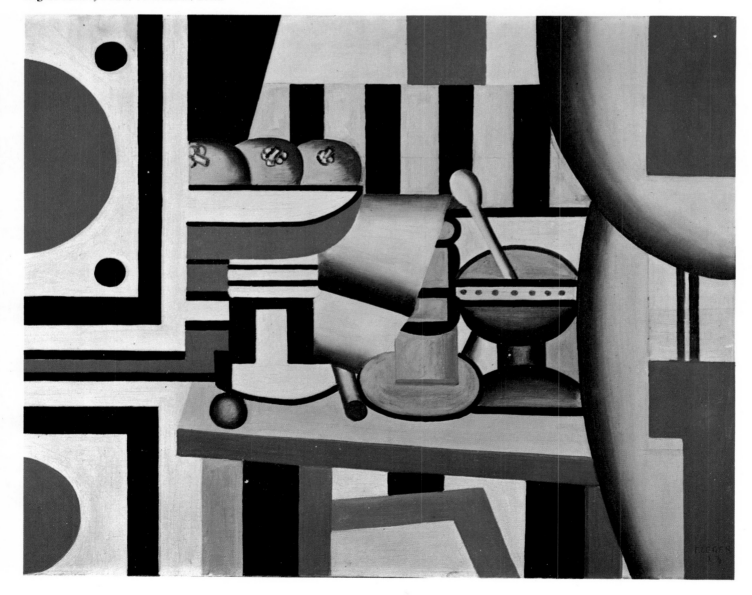

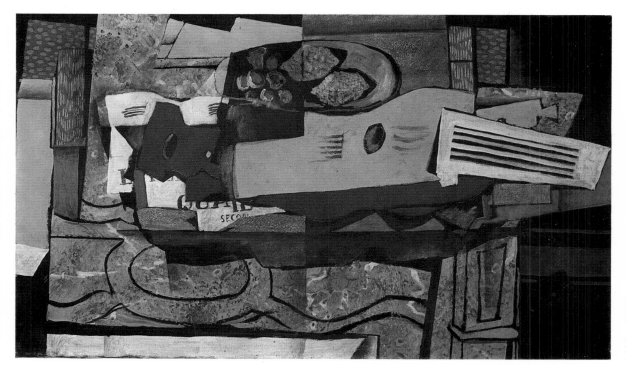

Braque: *Still-Life with a Guitar*, 72·5 × 99·5cm, 1920–2

Leger: *Woman and Child*, 171 × 241·5cm, 1922

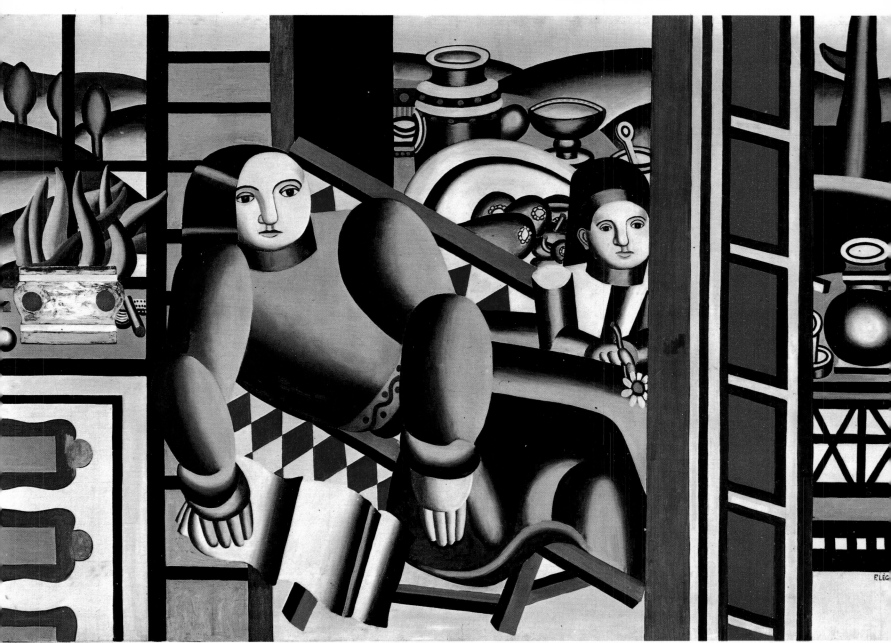

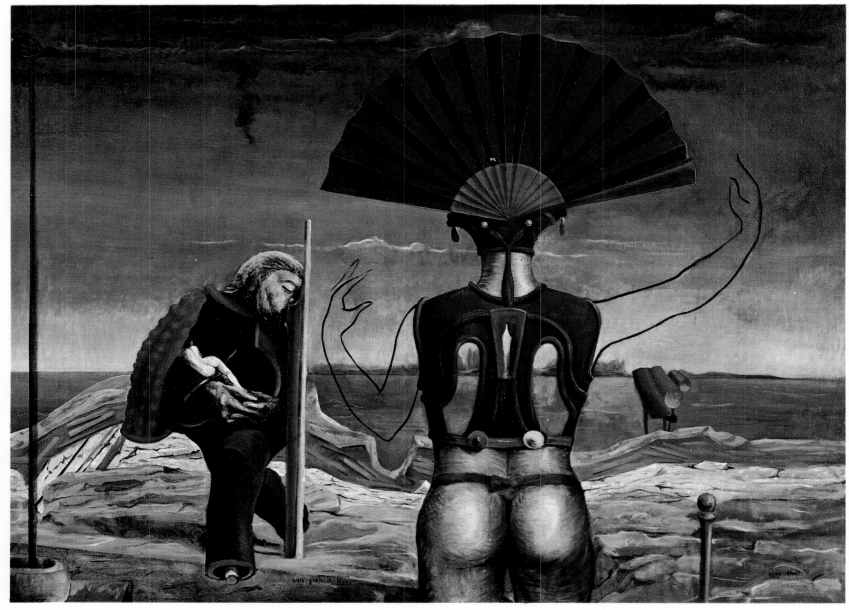

Ernst: *Woman, Old Man and Flowers*, 96·5 × 130·2cm, 1923–4

Hopper: *House by the Railroad*, 60 × 72·5cm, 1925

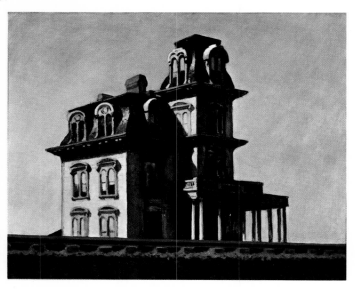

system, for its part, does not prepare would-be artists for the range of activities open to them when they leave the art schools.

Few contemporary artists have developed outside the system of art education which derives essentially from the nineteenth century but is tinctured with a few post-Bauhausian ingredients. Thus their conditioning is predominantly academic; and often their later, and ritual, rebellion lies in rejecting the conditioning. It is interesting that few art colleges have abandoned their traditional subject classifications. In the trendier institutions there are departments of 'Environmental Media', 'Inter-Media Studies' and 'Experimental Media', but they co-exist with departments of painting and sculpture. Art students are still *trained* as if painting and sculpture were central, important, and enduring activities.

The developments of the last fifteen or so years may come to be seen, not as a terminal crisis, but as a pause, representing a merely temporary crisis of confidence. What after all could be more natural? It is only through such momentary pauses that artists can take stock and criticize the nature and

Magritte: *The Man of the Sea,* 139 ×

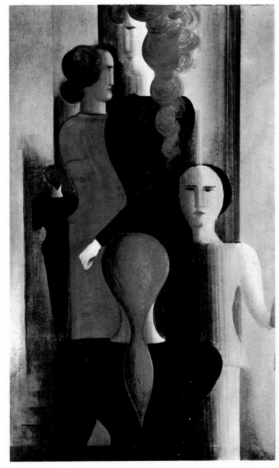

Schlemmer: *Series of Women,* 97 × 62cm, 1925

Klee: *Garden-City Idyll,* 42·5 × 39·5cm, 1926

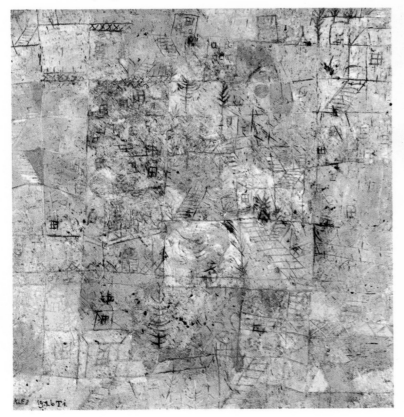

validity of their pre-occupations. This desire for a decisive 'break' may be conscious, but, nevertheless, not new, and it is in the examination of these breaks, and the conditions which led up to them — with the subsequent radical change in direction — that the fascination of the study of art history lies. Such breaks may be compared with the determination to force a schism between successive modes of representation, implicit, for example, in the advent of Cubism. The desire of the Futurists to create a machine aesthetic with its own dynamic is another example; in their case there was a similar desire to force a decisive break — to sunder and subvert the inheritance of *Beaux Arts* refinement. They still sought beauty, but in the strength of the machine, rather than in nature.

In surveying the successive breaks which litter the history of twentieth-century art one is drawn ineluctably to the con-

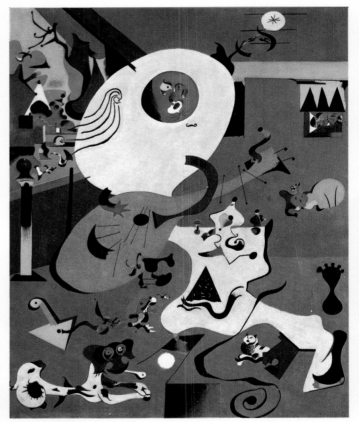

Miro: *Dutch Interior,* 92 × 73cm, 1926

clusion that activity in art represents not so much linear progression as cyclical movement. The concept that art advances has, at times of acute crisis of cultural confidence, been abandoned. Rather, the notion prevails that artistic activity is a process of constant re-appraisal, suggesting that the development of new artistic styles is closely related to the development of new conceptual modes. During the present century these have become more complex. The artist is successful if he produces art appropriate to a particular time. However, the general tendency during the last fifty years — recently it has developed rapidly — has been for art to aspire to the condition of science. This is not simply for the reason that artists include scientific and technological images and treat them figuratively, but because their approach to prob-

lem solving is that of the scientist, in that it is both abstract and empirical. There are periodic reoccurrences of certain themes: the re-examination of the values in which art has its basis — its role, function, and use for society; the destination of the finished art work; and the effects of the art market on the form of the work; the postulation of the end of culture; the possibility of a truly demotic art. All are persistent considerations.

As if to cock a snook at the over-solemnity and self-righteousness of those who think that art *can* be relevant to starving under privileged millions, and who think they have found *the* answer, the Surrealist impulse periodically asserts itself. In answer to the grinding objectivity of an over mechanized, objective-technological age, in various guises over the last fifty years, Dadaism displays its subversive, carnival role, pointing up the absurdity both of taking ourselves too seriously, and the grotesqueness of producing an art which does nothing to ameliorate the lot of the deprived. Often it is an assertion of nothing but a mischievous impulse and the value of nonsense. It has taken a number of forms. Duchamp (who, if twentieth-century art possesses a single

Magritte: *The False Mirror*, 54 × 80·9cm, 1928

Of Magritte, Suzi Gablik wrote: 'When it came to painting he manifested an almost constitutional dislike, feigning something between boredom, fatigue and disgust.' Magritte's is everyman's Surrealist and universally admired. His paintings commend themselves, at least in reproduction, for their craftsmanship and finish, and they appear almost Super-Realist. His work is deadpan initially — the viewer takes a few seconds to realize what is 'wrong' with the scene depicted. Being unaware of the meaning of the various symbols he uses is unimportant and does not detract from an appreciation of the painting. Mystification about the apparent lack of connection between a painting and its title is similarly nice to speculate about, but not of central importance. Magritte's forte was disjunction — between the real world and his depiction of it. It is in these slight and subtle shifts in meaning that his Surrealism lies. His speciality — the painting within a painting — is a further example of this disjunction; it is at once both a mystical experience which allows us to question the nature of reality and also the basis for considerable semantic speculation. There is no apparent reason or consistency in Magritte's work — he delighted in ambiguity. If we truly appreciate it, we do the same.

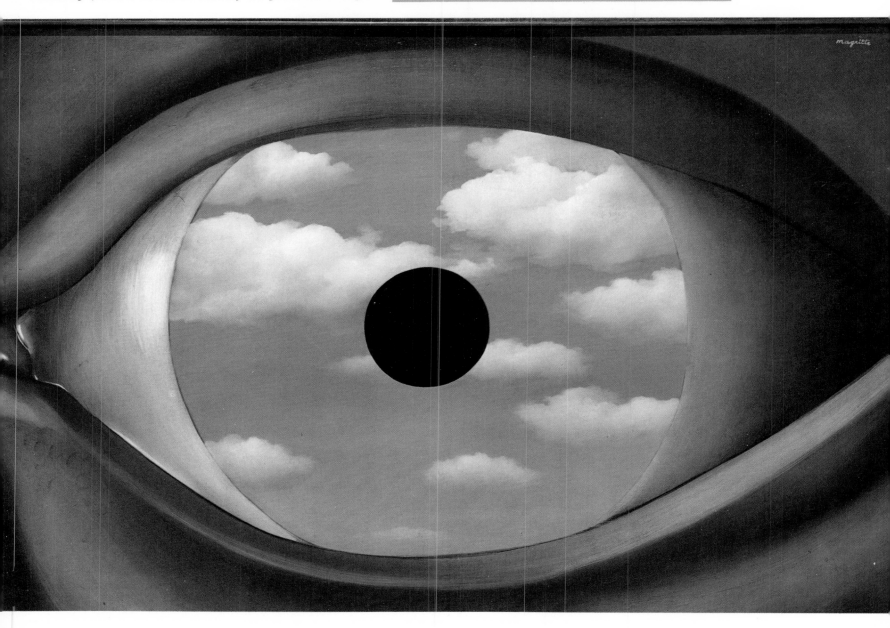

Arp: *Configuration; Navel,
Shirt, Head,* 145·5 × 115·5cm,
1927/8

guru, it is he) fostered the idea that 'whatever the artist chooses to be art *is* art'. He strove to avoid making positive aesthetic decisions and his solution was to present 'neutral' objects in an ambiguous way. His whole career was one of ambiguity, an epic piece of game-playing on the part of one who refused to reveal whether he was making art of living life. Even after 1923, when he ostensibly gave up art for chess (at his death it was discovered that he had been working on an ambitious secret art work) he continued producing what he called 'texticles' — world constructions, puns and other verbal jokes.

René Magritte is one of the masters of visual ambiguity. Apart from visual contradictions within his works, the titles themselves, which seem to have nothing to do with what is depicted, set up new resonances and new ambiguities, as is shown by *The Man of the Sea* and *The False Mirror*. The Surrealists, who specialized in images suggesting false meanings, were not doing anything essentially new. In literature, particularly that of Victorian England, the creation of new or distorted words ('twas brillig and slithy toves') by writers

Klee: *Settlement of Huts*, 77 × 53cm, 1932

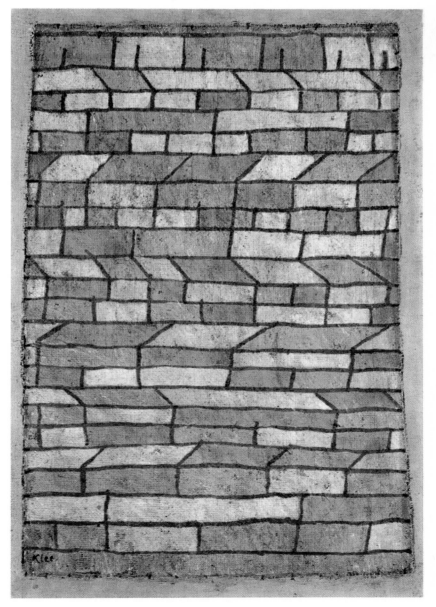

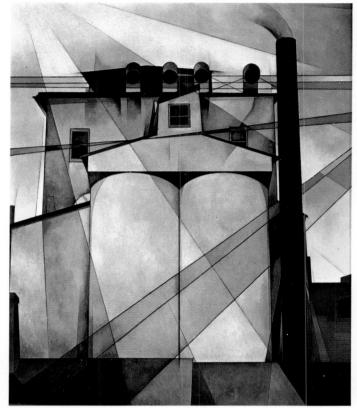

Demuth: *My Egypt*, 90·9 × 76·2cm, 1927

like Lewis Carroll anticipated them. Joyce's invention of his own language in *Finnegan's Wake* is a similar instance, and one can find many music-hall parallels. In visual art, Klee, Picasso, Dubuffet, Rauschenberg, Johns, and many others, emulated them. Often this fostering of ambiguity took the form of the introduction of new, so-called 'non-art' materials into art. Claes Oldenburg's great artist's statement-cum-poem:

> I am for an art that is political-erotical-mystical, that does something other than sit on its ass in a museum . . . I am for the art of neck-hair and caked tea cups, for the art between the prongs of restaurant forks, and for the odour of boiling dishwater . . . I am for the art of bright blue factory columns and blinking biscuit signs. I am for the art of cheap plaster and enamel. I am for the art of worn marble and smashed slate . . .,

articulates a new aesthetic standpoint — one in favour of unlimited assemblage. It is also the high point of a syndrome begun with the papiers collés and montages of Picasso and Braque, continued by Matisse, and by Max Ernst in the collages he made from nineteenth-century engraved magazine illustrations. As a practice the conversion of found objects into art was consecrated by such artists as Henry Moore and Barbara Hepworth. The Surrealists often preferred organic objects to manufactured ones, in that they bore a resemblance to human and animal shapes and were, therefore, more ambiguous. Moore and Hepworth were interested in the pure form of the objects they chose, which became the inspiration and starting point for more conventional work.

Dadaists like Schwitters, Duchamp and Arp revelled in

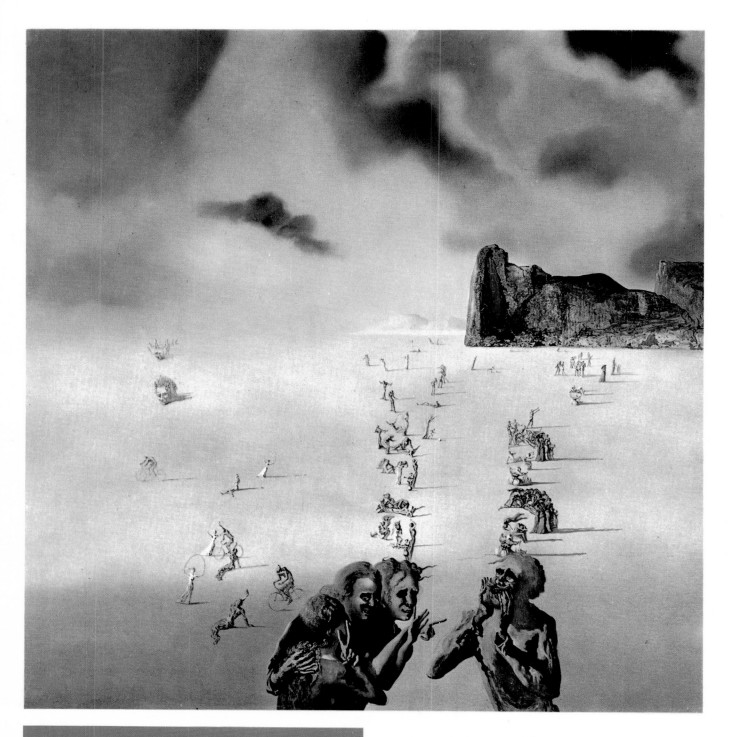

Dali: *Perspectives*, 65 × 65·5cm, 1932

Salvador Dali was outrageous even among the Sur-
realists who were enjoined by Breton in his Second
Surrealist Manifesto that 'the approval of the public
must be avoided above all . . . the public must be held
exasperated at the door by a system of taunts and
provocations.' At that Dali excelled; he wished to go
further than the others. As his whole career has been
outrageous in choice of his subject matter, so in life he
has broken almost every taboo. His paintings are dream
landscapes of phantasies and phobias, obsessive in
their highly personal eroticism. His iconography is that
of a terrifying dream-world, its constituent elements
conjured from his own unconscious mind. Psychologists
discovered 'that representational images in the human
imagination were related in a remarkable way to a fund
of such images stored in the unconscious, which
would only sporadically rise to the surface and then
involuntarily in dreams or in the free play of fantasy'.

PAGES 36—37 **Dali:** *Inventions of the Monsters*, 51·2 × 78·4cm,
1938

Feininger: *The Steamer 'Odin'*, 66 × 99cm, 1927

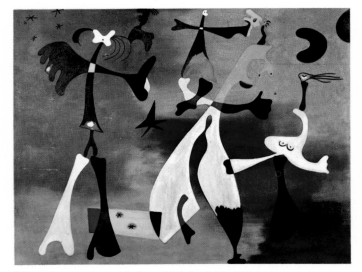

Miro: *Personnages with Star*, 196·5 × 248, 1933

the force fields of ambiguity set up by the natural object, but that was not their only purpose in using vulgar materials. Often they threw string, pieces of paper and other junk into the air and fixed them where they landed, creating works of 'chance'. They intended to demonstrate not only that they rejected traditional notions of order in making art, but also that they believed in the power of the unfettered unconscious mind, and the creative possibilities of chance. Artists have long felt free to exploit fortuitous chance effects in traditional modes, but to abandon the exercise of deliberate aesthetic choice was new. The desire to unleash what lay buried in the unconscious mind was presumably born as soon as the teaching of Freud gained currency. His theories gave rise to a new range of interpretations and associations for conventional subjects and symbols in art and in everyday life. The Surrealists response was a direct one: they simply painted dream images. But the Dadaists felt that products of gestures made with the minimum of conscious control had great value, and any idea of craftsmanship had to be abandoned.

The apparently uncontrolled gestures of Abstract Expres-

Beckmann: *The Departure*, 210 × 112·5cm, 1932/3

sionists such as Tobey, Pollock and, to a lesser extent, De Kooning, as shown in *Above the Earth*, *Grayed Rainbow*, and *Door to the River*, were like those of the novelist William Burroughs who cut the pages of his typescript and randomly reassembled them — a demonstration of the belief that the free-play of the unconscious mind had special vitality and value. Antonin Artaud would have rejected most of their solutions as unspeakably anaemic. The Surrealist principle has, as Sontag pointed out, also given birth to a 'certain kind of witty appreciation of the derelict, inane, démodé objects of modern civilization — the taste for a certain kind of passionate non-art known as "camp"' on the part of precisely that kind of polite society which the Dadaists and Surrealists repudiated. Artaud recognized that in dreams we penetrate the shallowness of 'psychological and social man'

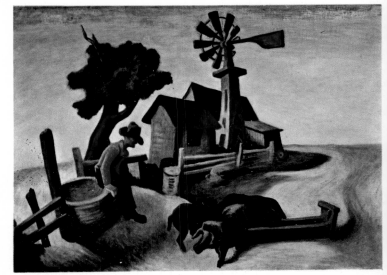

Benton: *Homestead*, 63·5 × 86·4cm, 1934

but for him that journey involved more than poetic fantasies. His Theatre of Cruelty was about the frustration of politeness, and, like Genet, he revelled in cruelty, eroticism and insanity, feeling that only in violence was man's true nature bared.

In an attempt to free art from the restriction of rigid thinking, over-categorization and the fetters of inhibition, various artists have explored alternatives, believing with Dubuffet that 'the characteristic property of an inventive art is that it bears no resemblance to art as it is generally recognized and in consequence — and this is the more so as it is more inventive — that it does not seem like art at all'. These investigations often fundamentally challenge accepted notions of what art is. Solutions to aesthetic problems have, almost traditionally, been sought in the formal solutions of so-called 'primitive cultures'. Latterly investigations have been made into child art, the art of the mentally ill and the art of the untutored as well as into 'primitive art'.

As a label, the word 'primitive' has so many applications as to be almost useless without a qualifier. It is used for the work of early nineteenth-century painters in the United States; it has been applied to such artists as Rousseau in Europe; and to this day it is used to describe untutored painters with a strong naive design sense and few ideas. Its first use, more indicative of prejudice than accuracy, was in

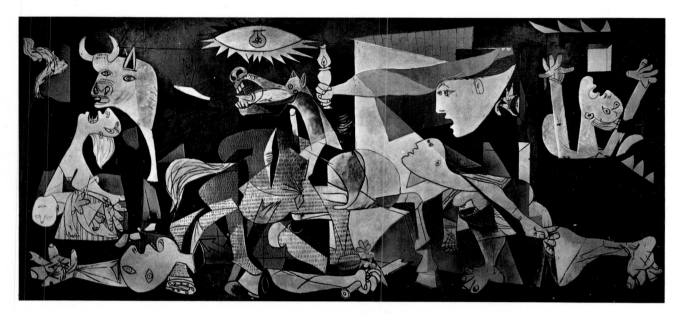

the mid-nineteenth century, to describe the works of medieval painters in France, Italy and Flanders. It was used indiscriminately of all painters of the Italian and Netherlandish Schools before 1500 and of all Italians before Raphael. Because of their 'honesty' and lack of complexity and sophisticated illusionism, characteristic Renaissance and later works such artists commended themselves to the Nazarenes, the Pre-Raphaelites and their followers. Conceivably, this was the beginning of the admiration by Western nations for products of less civilized societies. During a period of European colonialism tribute flowed in from

Rouault: *The Three Judges*, 74·6 × 55cm, 1938

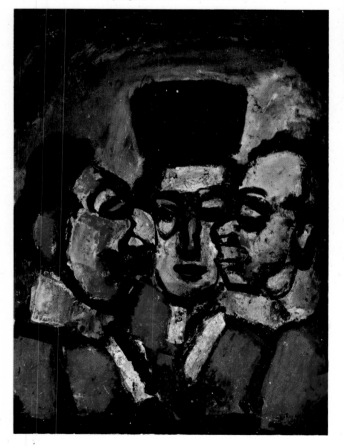

Picasso: *Guernica*, 349·3 × 776·6cm, 1937

Picasso seemed subconsciously to be preparing for this painting when he made his studies based on the Grünewald Isenheim altarpiece, which, with *Guernica*, is one of the greatest images of man's cruelty to man of all time. His bullfight scenes, his eviscerated horses, all seem to be building up to this work. In April 1937, in support of the Fascist leader, Franco, the Nazis bombed and flattened the small market town of Guernica — once the ancient Basque capital. Picasso reacted rapidly and made numerous sketches and oil studies. All stages of the work were photographed, and the whole project took under two months. The spirit of the work is as simple and accessible as the iconography is complex. *Les Demoiselles d'Avignon* may be his most important work art historically, but this is the one that fired the imagination of the world. Sir Herbert Read called it 'a monument to the vast sources of evil which seek to control our lives: a monument of protestation . . . a monument to destruction, a cry of outrage and horror amplified by the spirit of genius'.

abroad, and artefacts like African and Polynesian carved wooden masks and shields, and Japanese wood block prints became Victorian curiosities, regarded as being of anthropological interest. Later, Impressionist painters in France and Whistler in England came to realize what lessons could be learned from the distribution of flat space in the Japanese wood cut prints, in which an exquisite use of line was combined with the reduction of objects and figures to their simplest form. There is an absence of the illusion of depth; colour is used arbitrarily rather than to connote the real world.

For artists in the early twentieth century such as Braque, Picasso and Matisse the attraction of the carvings was their directness and simplicity. At first they collected them, and later they were influenced by them. The value was the same as that of medieval 'primitives' for the Pre-Raphaelites. In medieval paintings, scenes were superimposed in a total disregard of distance; what the artist regarded as important he exaggerated. In the Renaissance, that freshness and engag-

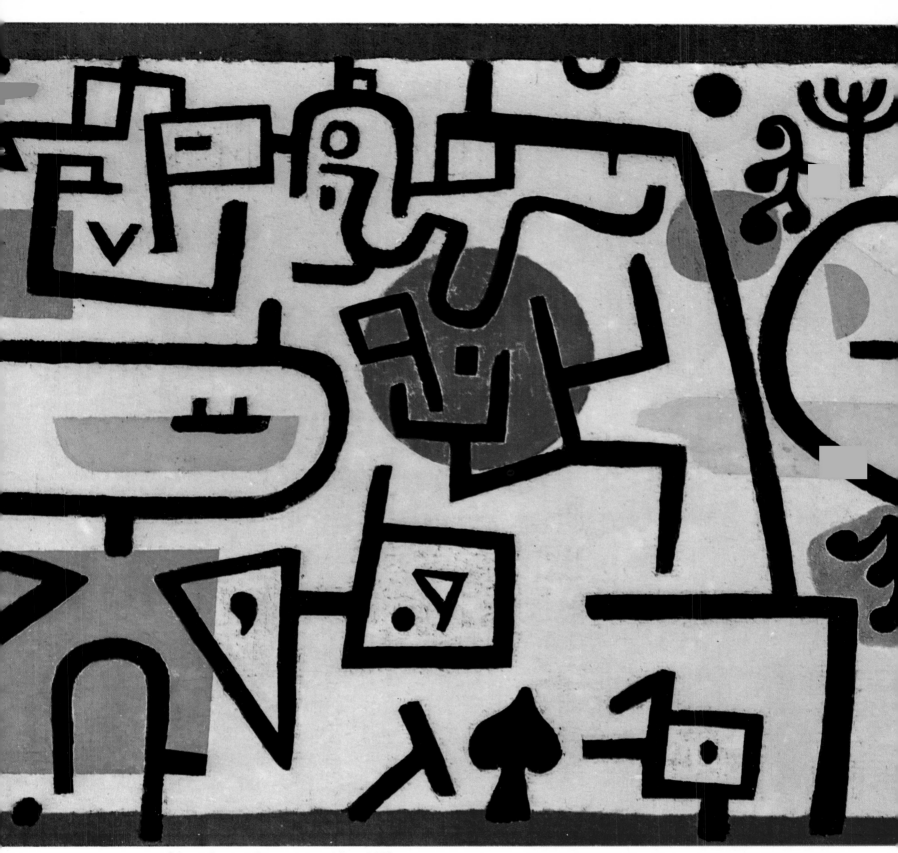

Klee: *Harbour in Bloom*, 75·5 × 165cm, 1938

ing honesty was lost through the development of tricks, and later, laws of perspective. In *Les Demoisselles d'Avignon* clear influences of ancient Egyptian painting can be found together with those of African tribal masks and sculptures of the Iberian Peninsula. Picasso saw nothing incongruous in combining all these influences with a drapery style that was reminiscent of El Greco's and the development of his advanced ideas. Interestingly, this enthusiasm for primitive and historical models was coincident with a rejection of the classical art that moved earlier artists in favour of archaic art, although Picasso went through a Neo-Classical phase later.

Throughout the century artists have sought to emulate the unspoilt naivety of 'primitive art', that of the 'mentally ill', and 'child art' – all terms which Jean Dubuffet described as 'patronizing', 'giving the impression that they are clumsy or aberrant attempts at "cultural art"'. In the case of child art, this is particularly so in England as its whimsicality has commended itself to English taste. It is the

40

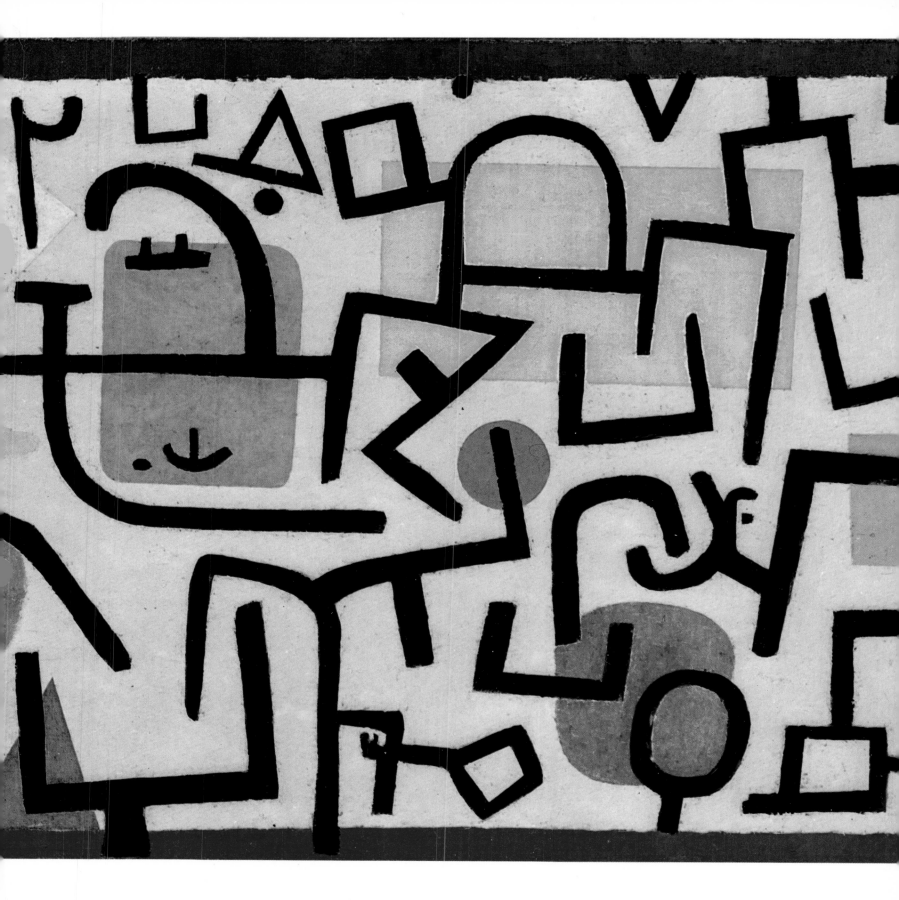

'innocent' aura of such works which has appealed to artists as diverse as Paul Klee, Miro, Dubuffet and Peter Blake, who have sought to achieve unspoilt childlike quality. In exploring the buried strata of the mind, artists might have been expected to present the primitive products of the collective unconscious, naked and unadorned, but this was not the case. Their drive to modify and embellish proved too strong. Partly the motivation of those who explored what Roger Cardinal called 'outsider art' was that of the Surrealists, but others sought to discredit the idea that mainstream fine art was sufficiently diverse to accommodate the expression of all sorts and conditions of men.

The corollary of the idea that mainstream art was all accommodating was the prejudice against anything which was aberrant. All extraneous expression was conveniently humped together by the prejudiced as a shapeless generality of ineptness and a failure to meet conventional standards. Dubuffet in his article, 'Art of non-conformity' (1970), postu-

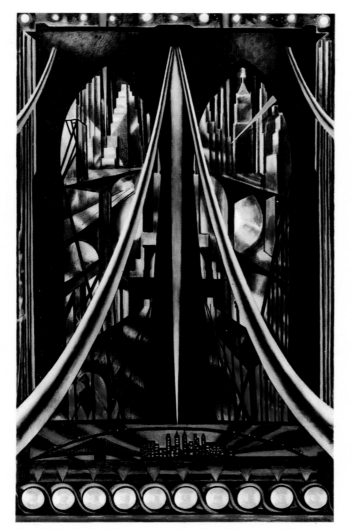

Joseph Stella: *The Brooklyn Bridge: Variation on an Old Theme*, 177·8 × 106·7cm, 1939

lated that there was a need, common to all, to create works of art, but he felt that societal pressures, favouring inhibition, led to the few who achieved liberation and who exercised their talents being classed as 'alienated'. André Breton admired the extreme primitiveness of Oceanic art, as opposed to the restraint of African art: the Surrealists saw madness 'as a creative rather than a destructive condition'. In 1945 *L'Institut Brut* was started; it consisted of the work of those working outside the mainstream cultural milieu. In 1948 the *Compagnie de l'Art Brut* was founded, and at its inception André Breton wrote:

> Here the mechanisms of artistic creation are freed of all impediment. By way of an overwhelming dialectical reaction, the fact of internment and the renunciation of all profits as of all vanities, despite the individual suffering these may entail, emerge here as guarantees of that total authenticity which is lacking in all other quarters . . .

Of late, the work of psychotics of whom Adolf Wolfli is probably best known, has achieved prominence, together with that of other 'aberrant' artists like Clarence Schmidt, Scottie Wilson and Madge Gill. Unfortunately, it is the decorative quality of their work that seems to appeal. Susan Sontag's strictures concerning the tendency of suburban man to import chichi kitsch junk as a result of post-Surrealist permissiveness, might equally apply here. The appreciation of this kind of work is due to its potential as witty interior decor rather than to a genuine sympathy and understanding.

As far as 'conventional' painting itself is concerned, travel along this particular continuum might be said to have ended with the bizarre extravaganzas of American artists like Karl Wirsum. His work in the mid-sixties like *Screamin' J. Hawkins*

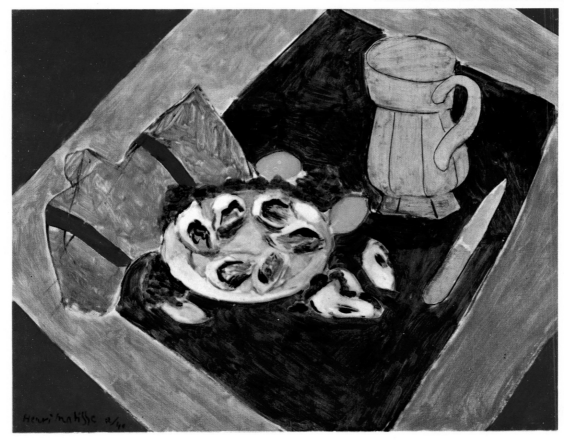

Matisse: *Still-Life with Oysters*, 60·5 × 81·5cm, 1940

much practitioners may have extolled the virtue of artistic anarchy and repudiated critical and aesthetic value judgements, the eventual outcome was generally the emergence of a clearly identifiable cohesive group or school who made something, susceptible to being called 'art', and mostly criticized or marketed as such.

At present, the frustration which predominates — that with the incestuous nature of Formalism — may be seen as yet further evidence of impatience with an hermetic self-indulgent art. But today a considerable artistic opinion is reasserting the value of purely formalist concerns, in an attempt to frustrate the hegemony of artists and critics, whose ideology advocates harnessing art in the service of (left-wing) politics. However, it has not succeeded. If we are to account for the vehemence of this backlash we must take into account the nature of painting and sculpture as establishment activities.

Art has been established as an item of commodity exchange. But because of the new spirit of egalitarianism, it is no longer acceptable that works of art are confined to a few private owners or, due to market manipulations languish unseen in the vaults of Genevan banks. Enormously powerful forces are at work to maintain the supremacy of painting as a practice: generally, the maintenance of these interests is not conducive to the wider dissemination of art or to the reduction of its exclusivity. When an organization like a pension fund or a merchant bank invests in art it is its rarity value that will increase their initial investment. There are commercial art dealers, who support art magazines financially, not simply in a spirit of altruism, but because the magazine ensures the continued relevance of painting. The attitudes of artists that art is no more than exchangeable

Grosz: *Approaching Storm*, 63·5 × 45·7cm, 1940

was at least suggestive of drug-induced psychedelia. Again, as in some of the poetry and literature of the period, the idea became current that creativity was enhanced by abandoning objectivity and self-control; the results generally indicate that it was not so. One fact emerges with clarity: however

Gorky: *Composition, 1941*, 73·7 × 102·9cm

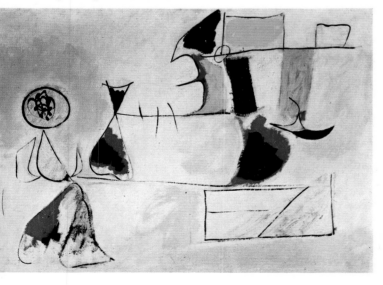

Mondrian: *Composition with Red, Yellow and Blue*, 72·7 × 68·9cm, 1939–42

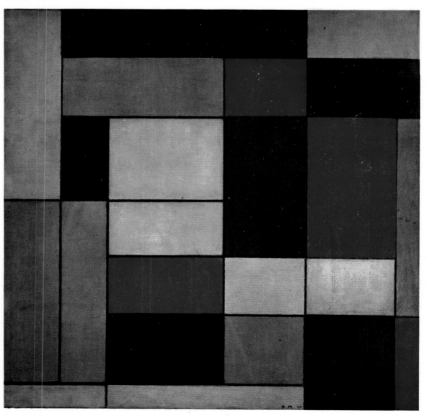

Schwitters: *Aereated VIII*, 49·7 × 39·5cm, 1942

As early as 1912–13 Braque and Picasso had started incorporating non-art materials into their work. Wall-paper, cigarette packets, newspaper and fabric were collaged onto their canvases. Earlier generations had painted, as tours-de-force, illusionistic still-lives, but they, believing that the act of painting illusionistically was redundant, preferred to incorporate real materials into their work. Later Matisse, in his papiers collés, first painted papers and then arranged them. Schwitters took as his raw material the found detritus of human society and transmuted unpromising source material into works which we now see as lyrical. Like Hans Arp, Schwitters arranged his compositions according to the laws of chance. His aim was the attainment of a pure art. He wrote: 'Even with garbage one can utter a cry . . . the point is to use broken pieces to build something new; art exists only as an equilibrium achieved by giving each part its proper value.'

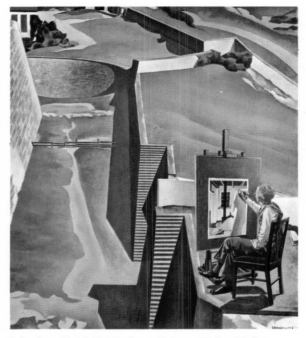

Scheeler: *The Artist Looks at Nature*, 53·3 × 45·7cm, 1943

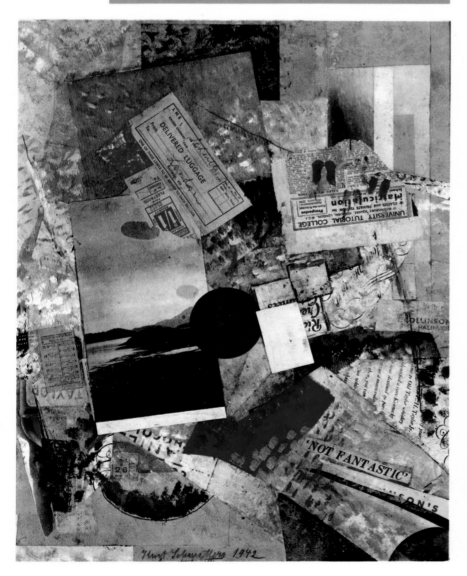

commodities is clearly a dead loss to a commercial art net-work that relies on regular sales of tangible goods to keep both artists and dealers happy, and in business.

Neither Formalists nor the practitioners of alternatives to painting fully face the truth that they are both part of the same elite, by virtue of the fact that they can luxuriate by discussing such esoteric themes while, for most people, as Picasso pointed out, an imperfect educational system has rendered art irrelevant. The identification of painting with institutions held to be culturally repressive and morally bankrupt in the rebellion of the late sixties also added to the widespread disenchantment. The status of painting was seen to the innately conservative and art the recreation of the few, rather than something accessible to all. There was also a general feeling of dissatisfaction about the apotheosis of art in 'cultivated' American Society and about the apotheosis of painting in particular, since painting was held to be the most arcane practice of art. Increasingly art was attacked both for its hermetic onanism and for the accretions of social prejudice and snobbery with which it had come to be identified.

Nash: *Pillar and Moon*, 50·8 × 76·2cm, 1932–42

OPPOSITE **Rivera:** *The Illusions*, 75 × 59cm, 1944

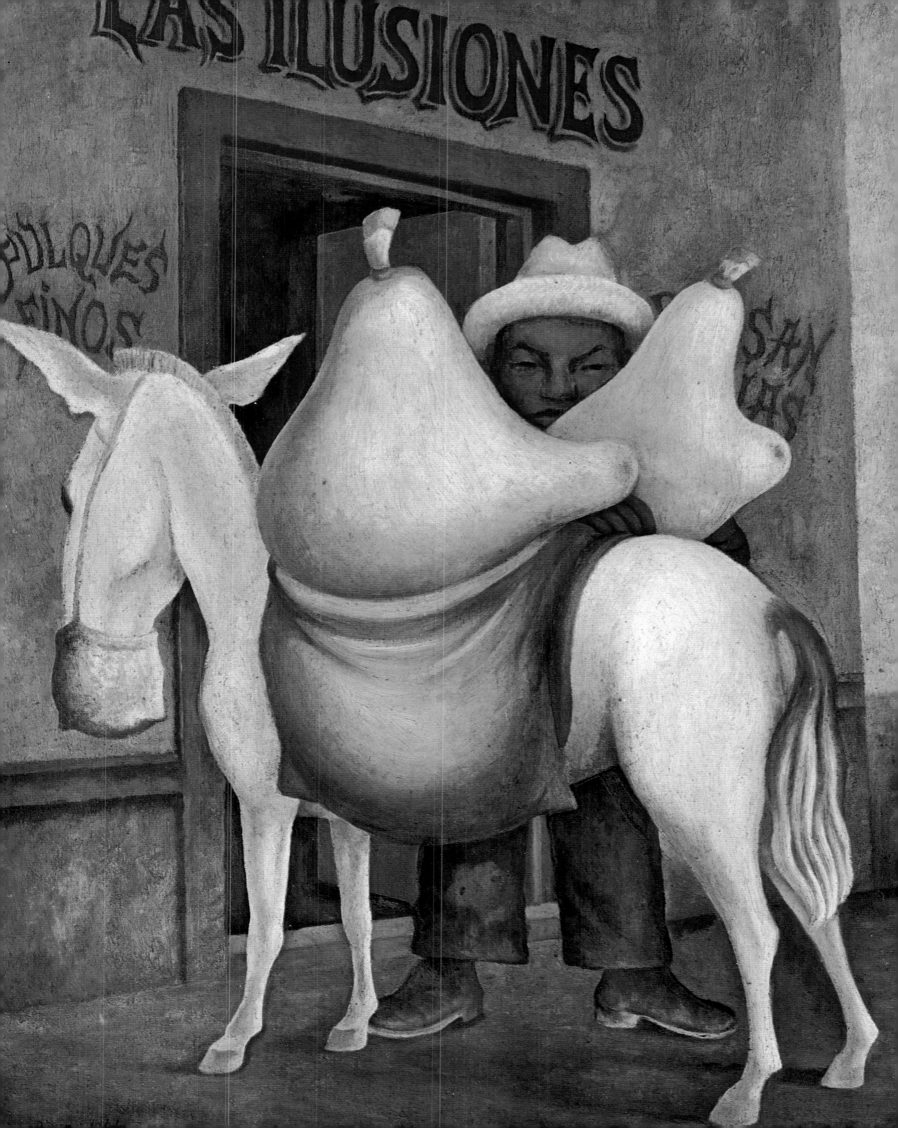

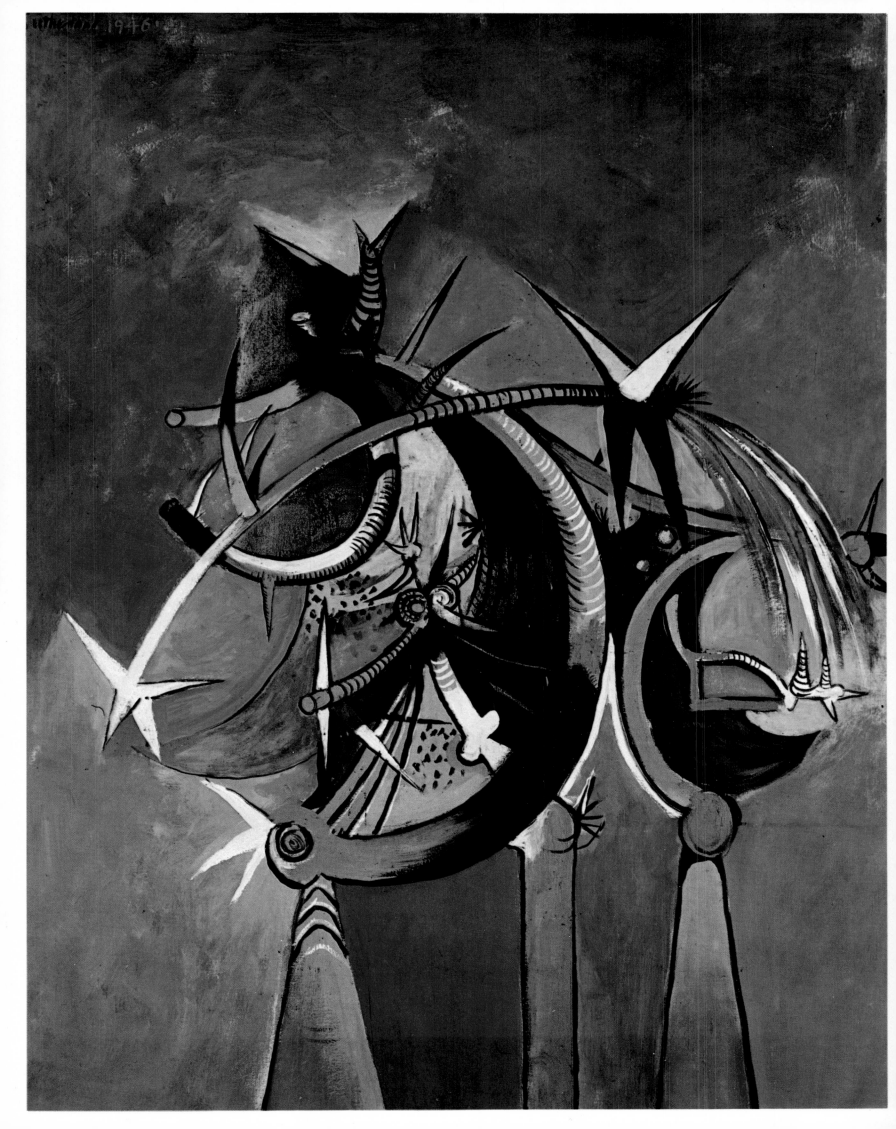

Kandinsky: *The Arrow*, 42 × 58cm, 1943

Pages 48–9. **Bacon:** *Painting,* 170 × 130cm, 1946

Francis Bacon is one of the few contemporary British painters to have achieved a worldwide reputation. He is a painter *par excellence* and obsessively explores his chosen theme, such as the Crucifixion, a pope, a mad dog, a bicycle, or an umbrella. His work has many sources, and is at once surrealistic and expressionist. In 1953 he superimposed a photograph by Edward Muybridge and a film still of a nurse shot in the eye (from the Odessa Steps sequence in *Battleship Potempkin*) in *Study after Velazquez: Pope Innocent X,* and for this he is credited with giving impetus to the Pop movement in England. His work is overtly violent; bloody cadavers, hypodermics and the fly-blown detritus of urban life, jostle in his canvases, and yet he conveys to them a dignity and an austere grandeur. His work ultimately resists categorization, for, although definitely English — his obsession with organic form (a test of Englishness) makes him at one with Sutherland and Moore — he is never in any sense tasteful.

The debate was not a new one for as early as 1919 Percy Wyndham Lewis, the Vorticist, was urging the destruction of the lyrical-pastoral ethic, and the development of a symbiotic relationship between art and the whole of modern society. He advocated an art which had what he called an 'organic' relationship with its time and not one sealed off into a socially privileged, idealized past. He said: 'Listlessness, diletanteism, is the mark of studio art. You must get Painting Sculpture and Design out of the studio and into life somehow or other.' Another event has been the drive on the part of twentieth-century artists deliberately to break the continuity with the past. But they have rarely denied the importance of stylistic cross-fertilization — it has become hugely complex with the introduction of 'non-art' materials, references and practices into art. In fact, the art-about-art references of 'alternative' artists are, paradoxically, far more prolific than those of the conventionalists.

This persistent disruption of the fine art continuum and its subsequent reinstatement has often taken the form of the deliberate assertion of the value of newness for its own sake. The practice came near to respectability in the sixties when

a number of people claimed that the major justification for art was its value in destroying existing orientations. Dubuffet gave his blessing to the artist's subversion by his statement, 'In my view the presence in a community of those members

Tanguy: *The Rapidity of Sleep,* 127 × 101·7cm, 1945

Tanguy's work falls into a number of distinct phases of which his aerial and desert scenes of between 1926 and 1939 are the most familiar. Strewn with invented amorphic objects and unidentifiable dream-creatures, his landscapes of the mind are derived obliquely from the Breton sea shore of his childhood, and, if no less disturbing, pale into genteel lyricism beside the sadistic excesses of Dali's treatment of similar themes. His work lies close to the sources of Surrealist art, and his drawings are deliberately childlike scratchings, reminiscent of occult symbols and the religio-magical cave paintings of Altimira and Lascaux. Yet, as with much Surrealist work, it is the stillness of these scenes which is disturbing — if there is a threat then it is a quiet one — as though time itself had been dislocated. In 1939 De Chirico went to America where his dripping amoeba shapes became almost calligraphic, and, with those forms of Robert Matta, became an influence on the younger Abstract Expressionists.

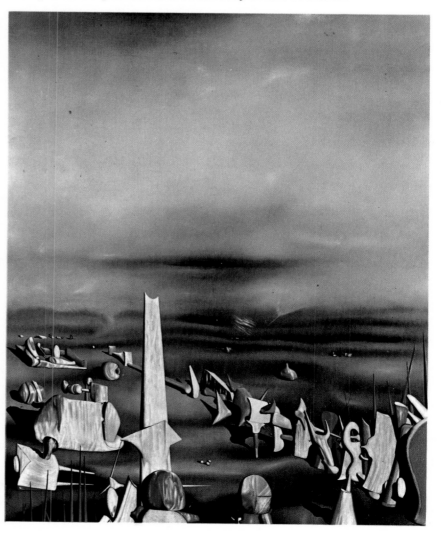

OPPOSITE **Sutherland:** *Thorn Heads,* 122 × 91cm, 1946

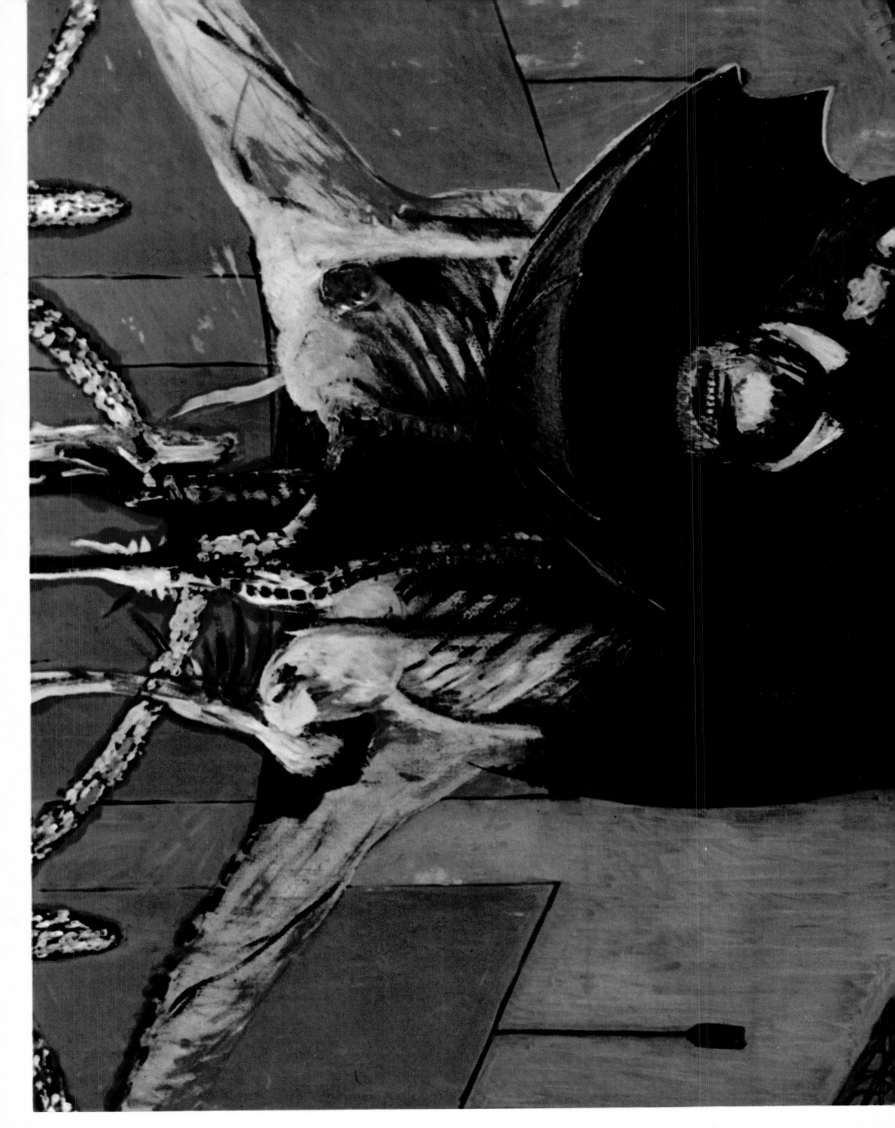

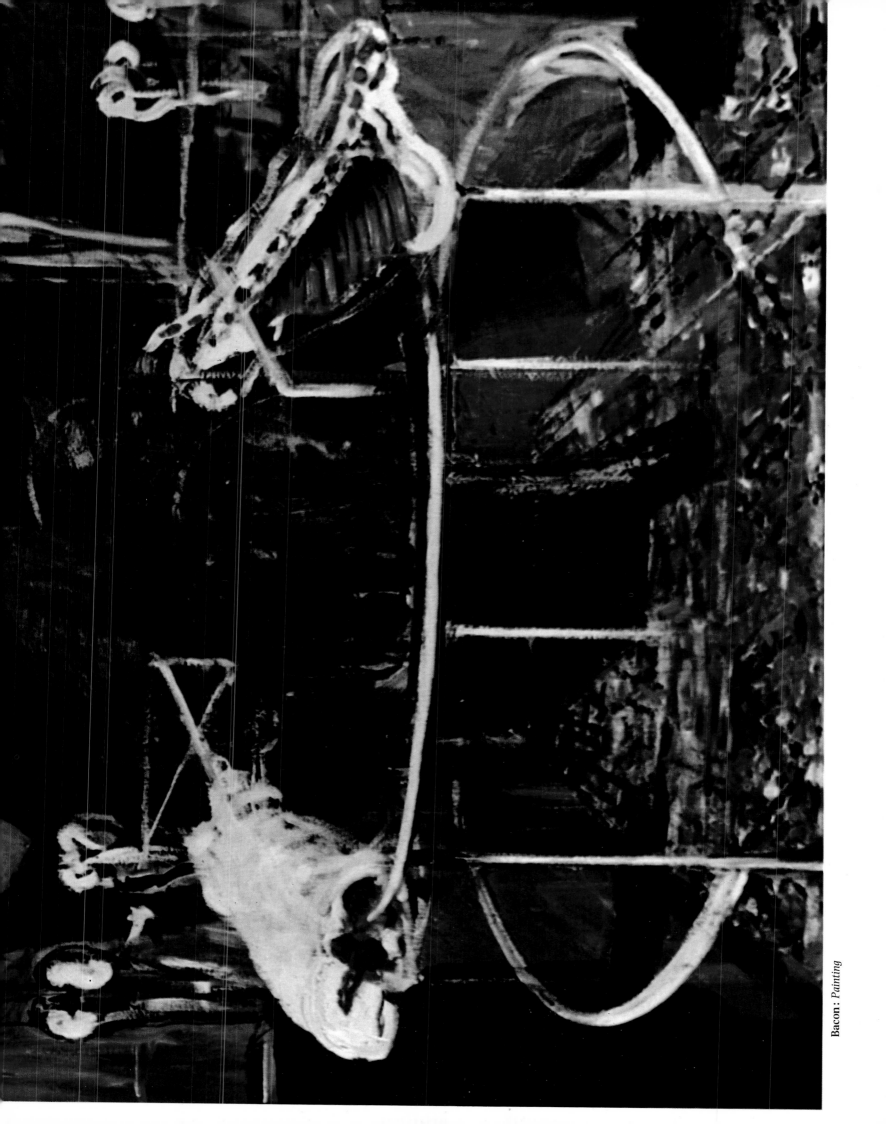

Bacon: *Painting*

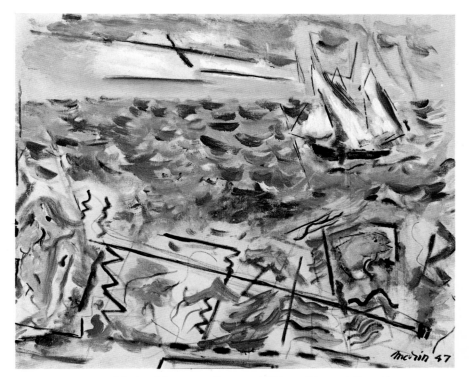

Marin: *Movement: Boats and Objects, Blue and Gray Sky,* 73 × 92·1, 1947

who question accepted values is a healthy sign.' In *Man's Rage for Chaos – Biology, Behaviour and the Arts* (1966), Morse Peckham claimed that the responsibility of the artist was to get society out of those ruts into which it was prone to fall: 'Art is the reinforcement of the capacity to endure

Wols: *Harmony in Red, White, Black,* 99 × 77cm, 1947

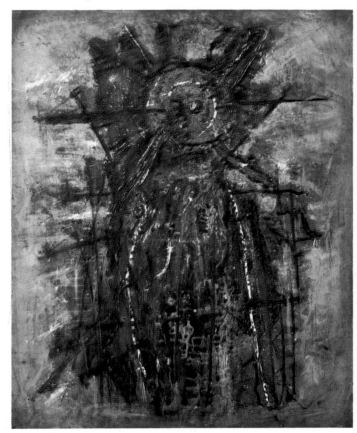

disorientation so that a real and significant problem might emerge.' Peckham's theories are the reverse of conventional ones, which regard art as the seat of order. He demonstrates how all art forms, from time to time, frustrate the human demand for order. He sees the defining attribute of artistic experience as exposure to perceptual disorder. He had his critics: Professor E. H. Gombrich felt that he had confused 'stylistic drift' with a desire for change. In his essay 'Art at the End of its Tether', Gombrich claimed that Peckham was so shocked and disorientated at his first encounter with the contemporary avant garde that he went in search of a persuasive theory in order 'to justify the ways of art to man by inventing a new theory that fits the contemporary scene'. But Peckham had his supporters among artists and commentators. In her comments on Happenings, which she sees as a Surrealist phenomenon, Susan Sontag recognized the value of the extreme dislocation of reality involved in provoking laughter. Essentially the Happening was an example of disorder/dislocation, with its ambiguities of scale, its

Shahn: *Mine Disaster,* 61 × 76·3cm, 1948

Shahn is the leading exponent of the North American School of Social Realism which emerged during the American depression of the 1930s. As well as acting as a vigorous prompt to the conscience of the nation he has written prolifically about art and is a gifted teacher. He is a well loved illustrator and for this he is probably best known abroad. His work is best characterized by its sense of humour: even when most outraged by injustice, as in his *Passion of Sacco and Vanzetti* series, he eschewed the direct comment and allowed his viewers to form their conclusions. When President Roosevelt set up the Federal Arts Project in the Works Progress Administration it was an attempt to give to Americans 'a more abundant life' by bringing art in greater quantity and quality to the mass of people. To towns where there had been no original art the F.A.P. took over 2,500 murals, 17,000 sculptures, 11,000 designs, and 108,000 easels! Shahn worked as a muralist and, like many others, was heavily dependent on the example of earlier mid-Western regional artists, feeling that realism was the best way to communicate with the untutored audience.

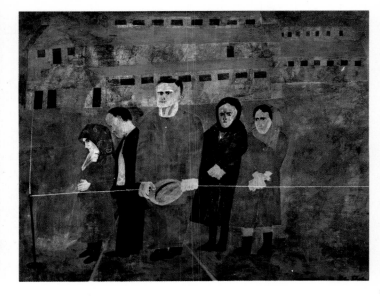

OPPOSITE **Miro:** *Figures and Dog in front of the Sun,* 81 × 54·5cm, 1949

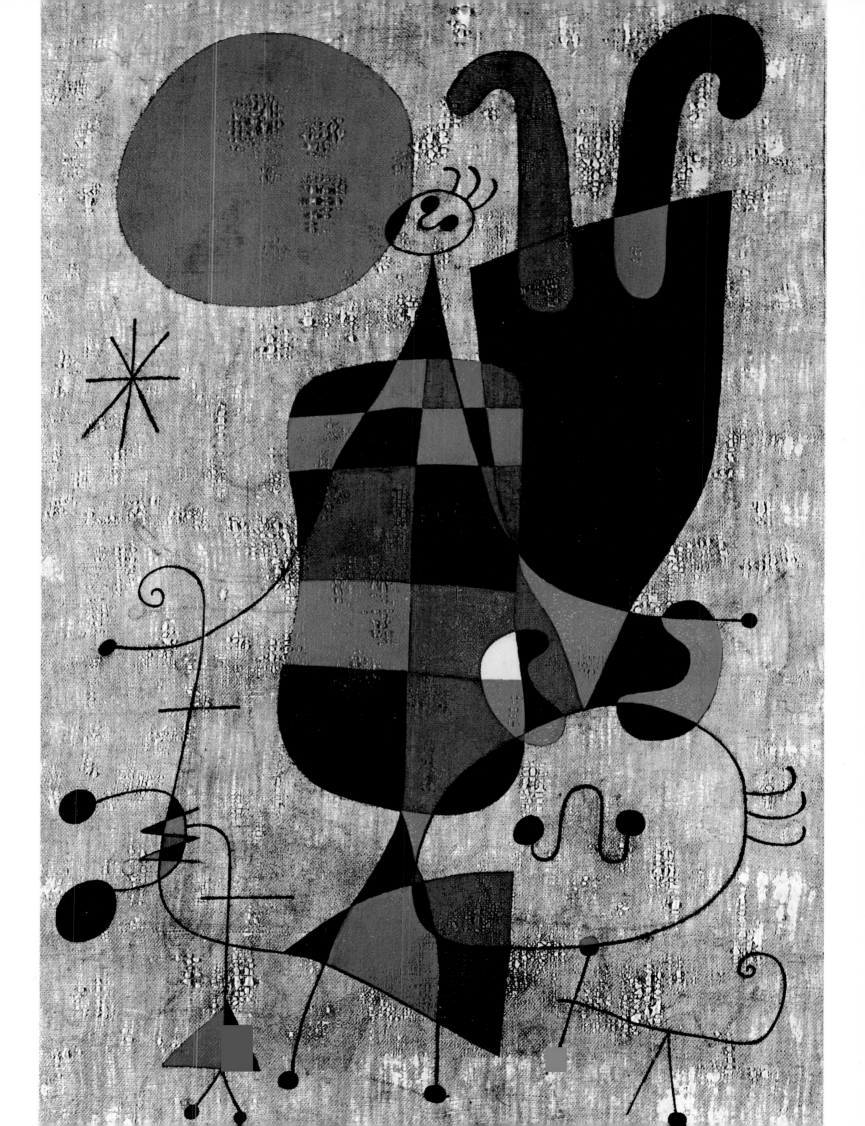

In Newman's paintings the theme is the content. There is a total lack of recognizable imagery. His aim was that of many of his contemporaries — the elimination of subject, with each painting standing, and being sufficient in itself, without reference to the external world. Born of the post-war angst, which gave Existentialism to Europe, the Abstract Expressionist movement took upon itself the peculiarly American characteristics of scale and self-confidence when it invested what superficially seemed mere arrangements of colour and form with profoundly emotive qualities. There was an august indifference to the 'problem' of relating art to everyday life; the spectator takes from the paintings what he can, and is invited to respond to them emotionally. There are no answers. Harold Rosenburg, in rejecting Thomas B. Hess' epic piece of interpretive scholarship (he attempted to relate the works to exalted mystical experiences revealed in texts in Newman's library), said: 'For Newman painting was a way of practising the sublime, not of communicating it.'

orientation and strife, of violent discontinuity and mutability, of the willingness for confusion even in the service of discovering new perceptual modes' (1970). But it is important to remember that the disruptions and destructions of artists were never purely destructive; even in Dadaism there was the implication at least of a substitute set of values — rather than absolute nihilism.

Unfortunately, in about the last fifteen years innovation in art seems to have become a completely mindless end in itself. Harold Rosenburg has written of this, and he places responsibility principally on the pressures of the mass media and, curiously, on the museums. Modern art history he depicts as a series of 'black-outs' — the eclipse of one phenomenon resulting in the high lighting of another 'When is an art movement dead? When the publicity spotlight has

Matisse: *The Snail*, 286·2 × 286·8cm, 1953

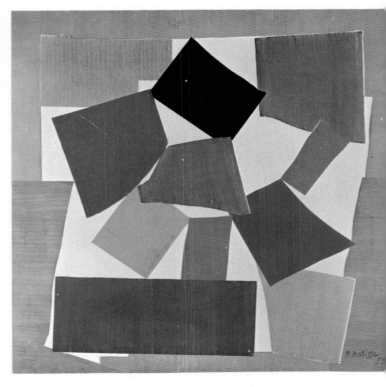

'radical juxtapositions and its obsessional urge to disorientate the audience'. Dubuffet said: 'Art is certainly not expected to be "normal". On the contrary one can say exactly the opposite without much fear of contradiction. It would be better to declare the creative process of art in any field as being the product of a pathological condition.' Robert Morris too saw art as 'an activity of change, of dis-

moved off it'. This is a frequent theme in modern art criticism, and it has increasingly been articulated since art moved so firmly into the market place in the sixties. It is the crippling, albeit often unconscious, search for 'newness' which has confined the artist, and confused his potential audience. The by-product has been the dismissal of art history by artists who, wishing to escape categorization, concentrate on presenting their ideas in impermanent modes.

Yet, that complete newness is as chimerical as 'progress' which the illustrations in this book obviously show. It is chastening, but true, that even the most avant-garde manifestations, when closely examined, prove to have their precursors. Nor does it seem, when we compare Wyndham Lewis' statement of 1919 with some of the shriller artists' statements of the present, that we have advanced much. For instance, it has been suggested that contemporary painting is no longer 'art' because it lacks an essential ingredient that art must have – namely *modernity*. Now these are very loaded words, but if we ask ourselves how modernity relates to art, then we conclude that it must communicate culturally compelling ideas, whether these merely concern art itself, or relate to other intellectual disciplines. In other words, modernity might be about the wider issues of the contemporary world, or simply about formal aesthetic problems.

As the twentieth century has aged, artists have, with one or two notable examples, come to be increasingly con-

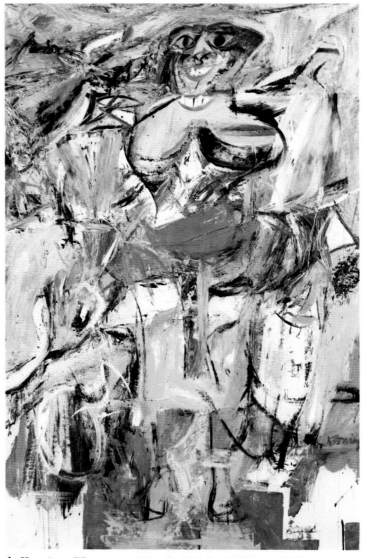

de Kooning: *Woman on a Bicycle*, 194·3 × 124·5cm, 1952–3

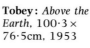

Tobey: *Above the Earth*, 100·3 × 76·5cm, 1953

de Stael: *Study at Ciotat*, 33 × 45·7cm, 1952

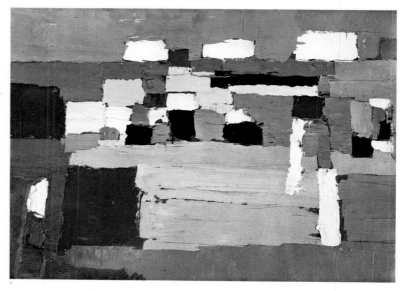

cerned with establishing a dialectic with other areas of human endeavour. These have tended to be scientific-technological in the recent past, but in the seventies artists have embraced such diverse fields as linguistics, semiology and anthropology. What has resulted is the considerable expansion of former notions of art practice. This has been a selfconscious quest, and, apart from usual areas of advance (like the development of new metaphors and new media), it has involved the search, albeit a fruitless one, for a new audience.

A by-product of this dialogue with other intellectual fields has been the incorporation of their modes and vehicles of expression into art, with the result that the traditional modes, seeming stale and less exciting, either have become diluted

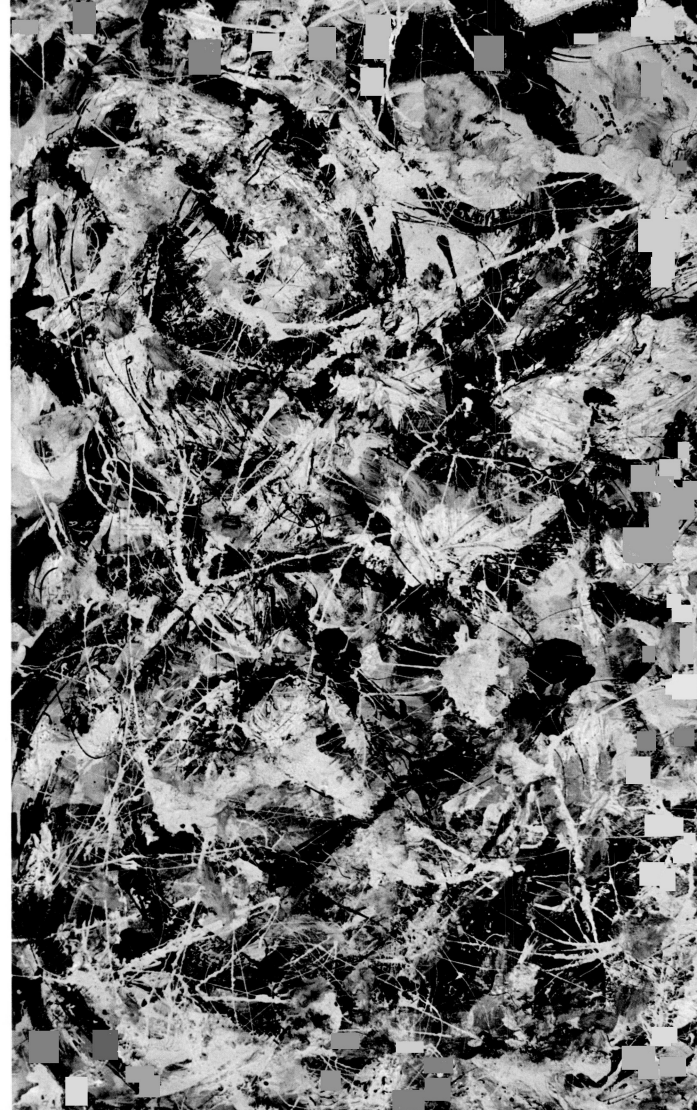

Pollock : *Grayed Rainbow,*
182·9 × 244cm, 1953

54

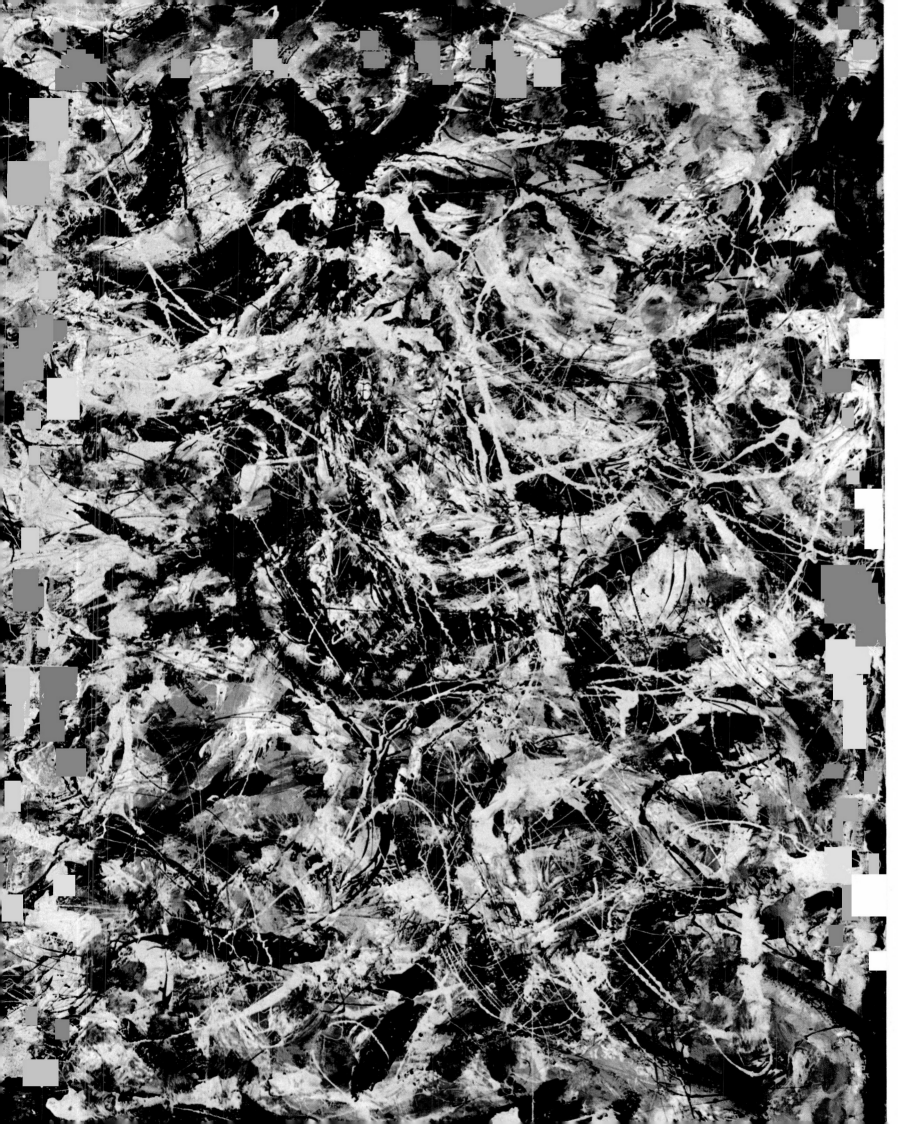

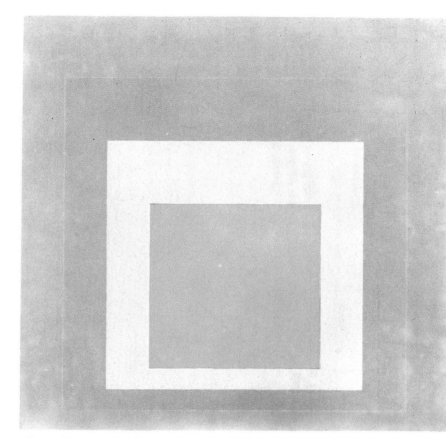

Albers: *Hommage to a Square: Ascending*, 110·5 × 110·5cm, 1953

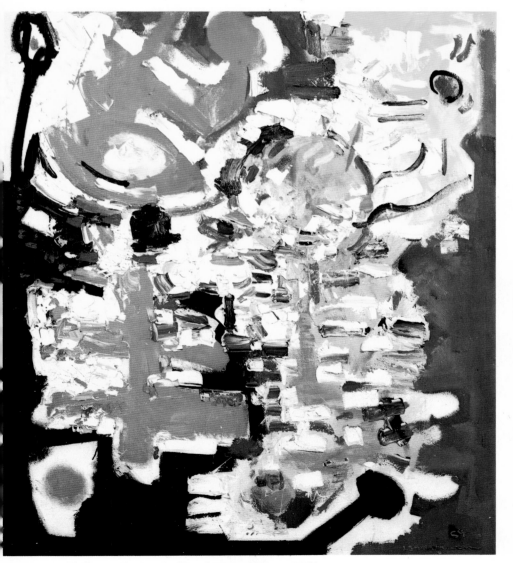

Hoffman: *Fantasy in Blue*, 152·4 × 132cm, 1954

or have surrendered in the face of alternative possibilities. From this it was a short step to the fundamental objection to painting as a modern cynosure, which was that it was no longer an appropriate medium for the most felicitous expression of the complexity of society. David Sweet pointed out in *The Future of Painting* (1971) how painting, unable to fulfil the role of modernism, finds itself in a culturally insecure position, having in a very short time lost both the motivation of its former raison d'être and the patronage of its former audience. Sweet comments:

> Obviously this situation creates severe problems for individual painters: if they wish to continue making Art they must leave the parish in which their morphology resides to work on the frontier of a wider territory. . . . If, on the other hand, they wish to continue painting they must either apply to the *Formalist Academy*, . . . or seek an alternative source of validity to that conferred by modern art, which does not necessitate any rejection of their morphological terms of reference.

It has also been argued that another future for painting may lie in a proud proclamation of its limitations. With a firm rejection of scientific and technological belief in progress, it has been claimed that painting might be of use in mitigating the more alien and depersonalizing aspects of a mass society by attempting to reassert the humane dimension that it increasingly lacks. But the disadvantage of this particular argument is that there is no evidence, so far, of any willingness on the part of painters to reject the pressures on artists of a mass consumer society. On the contrary, it seems that they celebrate it, despite its dehumanizing features.

Formalism is damned as life-denying and a retreat. Those who condemn painting dismiss it with the claim that its practice has degenerated into formalism and incestuousness. Those arguments which used to delineate the redundancy of all modern art can be applied even more convincingly to painting. The internalized nature of art debate, its sterility, its many allusions to past art and contemporary practice have resulted in the mystification of even its once most dedicated intellectual audience. Critics compound this process of alienation. Instead of attempting to educate the wider public

Rothko: *Painting*, 265·4 × 297·8cm, 1953–4

The Rothko Room in the Tate Gallery has been described as 'one of the most serious and solemn places on earth'. Its constituent paintings, originally intended for the Four Seasons Restaurant in New York, are, like almost all Rothko's work, large oblongs of diffused colour in vertical rectangles, in which the intensity of the colours at the centre of each oblong becomes diffused and blurred. Each area of colour seems to expand spatially and appears to bleed over the edge of the canvas. It is an art of the senses — Pater's statement that 'all art constantly aspires to the condition of music' might have been occasioned by one of Rothko's paintings. Deriving from Expressionism and making even the palest Abstract Expressionist works seem brash by comparison, his work is profoundly spiritual and intensely personal. An observer would have to be insensitive indeed to need explanation or interpretation.

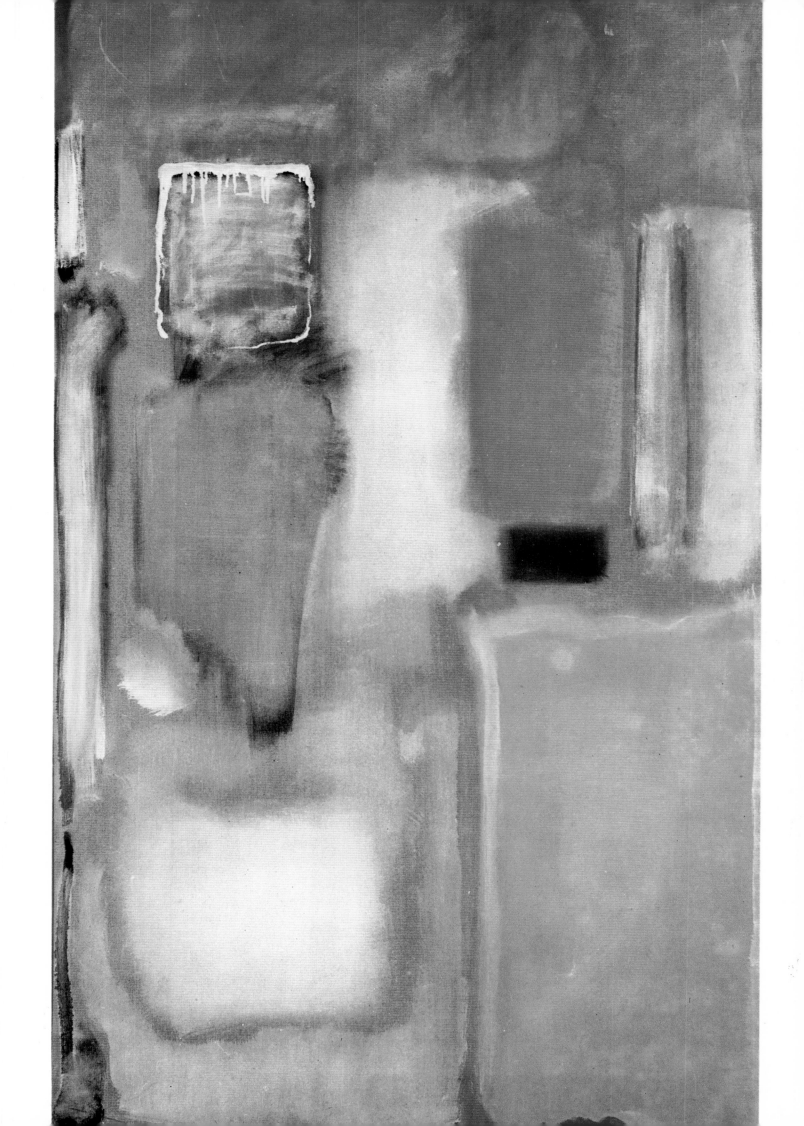

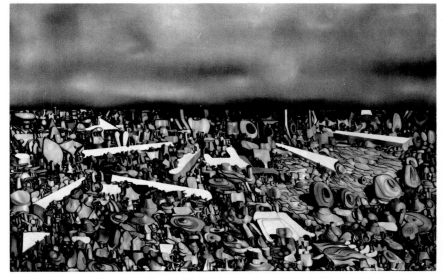

Tanguy: *The Multiplication of Arcs*, 102 × 152cm, 1954

arts as one of many 'secondary signs of the ataraxy of the British Art sector' — '"community arts" are a travesty of the term, rarely rising above the level of over-subsidized party games'. They are practised by many artists who are held to be neglectful of the public through their indulgence in esoteric peripheral activities — far from the appreciation of the broad mass of people. Critics, British ones particularly, like Richard Cork of *Studio International* and Caroline Tisdall

Giacometti: *Portrait of Isaku Yanaihara*, 81·3 × 65·2cm, 1956

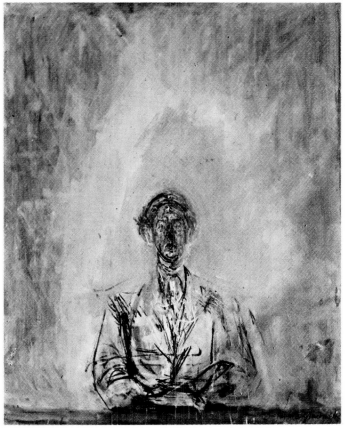

about art and trying to relate art to the society which produced it, they turn their back on the lay audience, xenophobically choosing to address the cognoscenti only. They have become so mesmerized by their own dialectic that they cannot see wood for trees. Their myopia leads them to ignore the larger problem of establishing a simple dialogue between the artist and the conditioning society. Those who saw the answer to the problem of insularity in increased commerce with the pseudo-democratic, so-called 'community arts' have been similarly confounded. One critic saw community

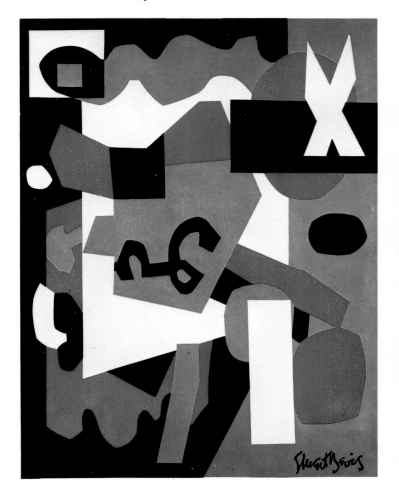

Davis: *Ready to Wear*, 142·9 × 106·7cm, 1955

The art of Stuart Davis had its roots in American Social Realism. He was taught by Robert Henri, a member of the 'Ash Can School', who, repudiating the usual art school, beaux-arts practices of the time, sent his students to draw the American scene in all its rawness. He exhibited at the Armory Show in 1913 where he saw Cubist paintings and the Fauvist works of Matisse and was attracted by their 'broad generalizations of form and the non-imitative use of colour'. He experimented with collage in the manner of Braque and Picasso, but varied their technique by painting imitations of printed ephemera on his collages. Some of these are held to be precursors of the Pop Art of the nineteen-sixties, but his work also possesses affinitives with 'Op' and 'Hard Edge'. His work is at once serious and playful; it often possesses the totemic grandeur of Picasso's *The Three Musicians* and shares its carnival frivolity, communicating joy and excitement. His achievement is not only to have anticipated a whole range of later developments in art, but to have transcended changes in style and fashion, retaining the respect of his avant garde successors.

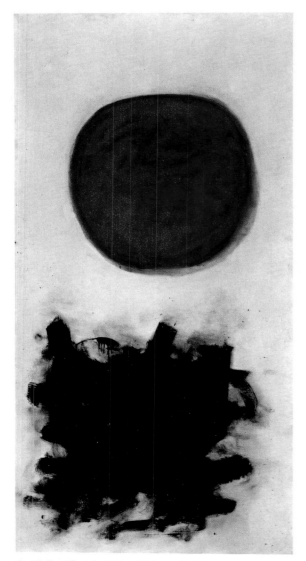

Gottlieb: *Blast I,* 299 × 115cm, 1957

a culturally significant occupation. In Britain there was a curious reassertion of its values by that formerly beleaguered cultural élite which had administered public galleries and funding bodies. They were innately conservative, operating a version of that modish ruling taste, well tempered with merchant bank pragmatism, which had allowed them to commission, market and live with both the large canvassed augustness, and profitable vulgarity, of sixties' art. Emerging from its retreat, the result of the *putsch* of post-market, post-object Conceptualism, they attempted to reassert themselves in England during 1977, encouraged by the coincident advance of post-permissive puritanism. As if encouraged by the change in the temper of the times the painters Peter Blake and Ronald Kitaj, both of whose work was figurative though the latter's less so, took the offensive against those critics favouring the exploitation of art as a catalyst in the process of social and political change (which clearly precluded highly-marketable, bourgeois, realism). They proclaimed a renaissance of figurative painting. 'Don't listen' wrote Kitaj, who thought that Bacon was the finest painter alive, 'to the fools who say either that pictures of people can be of no consequence or that painting is finished. There is much to be done.'

Essentially the battle was a political one: the left-wing critics who were, by implication, 'anti-gallery' and in favour

Nolan: *After the Glen Rowan Siege,* 122 × 91cm, 1955

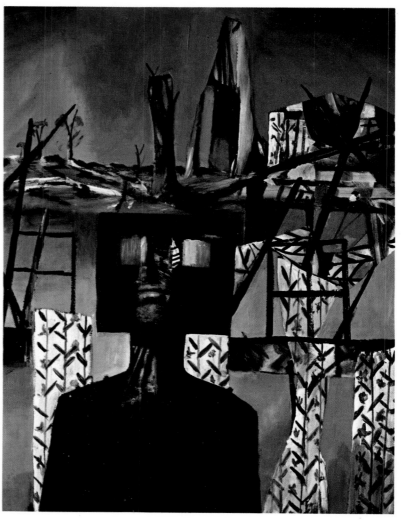

of the *Guardian,* asserted the need for art to take on, regain, a social and political dimension. They feel with the American critic G. R. Swenson that 'a revolution . . . needs its artists perhaps most of all. And none of us has been doing enough. Let there arise in our midst a cry for Freedom: of spirit, of person, of social conscience' (1968). In 1978, in an interview, Cork said:

It is quite obvious to anyone who goes to a modern exhibition that the life experienced . . . in 1977 is hardly being alluded to in any form whatsoever neither literally nor metaphorically. I would like the painters of monochrome canvases to ask themselves precisely what their works of art mean, just as I would like to ask the painters . . . who are purportedly 'realist' and yet restrict themselves to pots of flowers on a window sill . . . why they are not even beginning to think about tackling subject matter outside their rarefied middle class havens.

In answer to the ascendancy of what one might crudely categorize as the 'anti-painting' school of criticism there was a curious backlash from the (equally crudely categorized) *derrière garde* who felt it was possible to maintain painting as

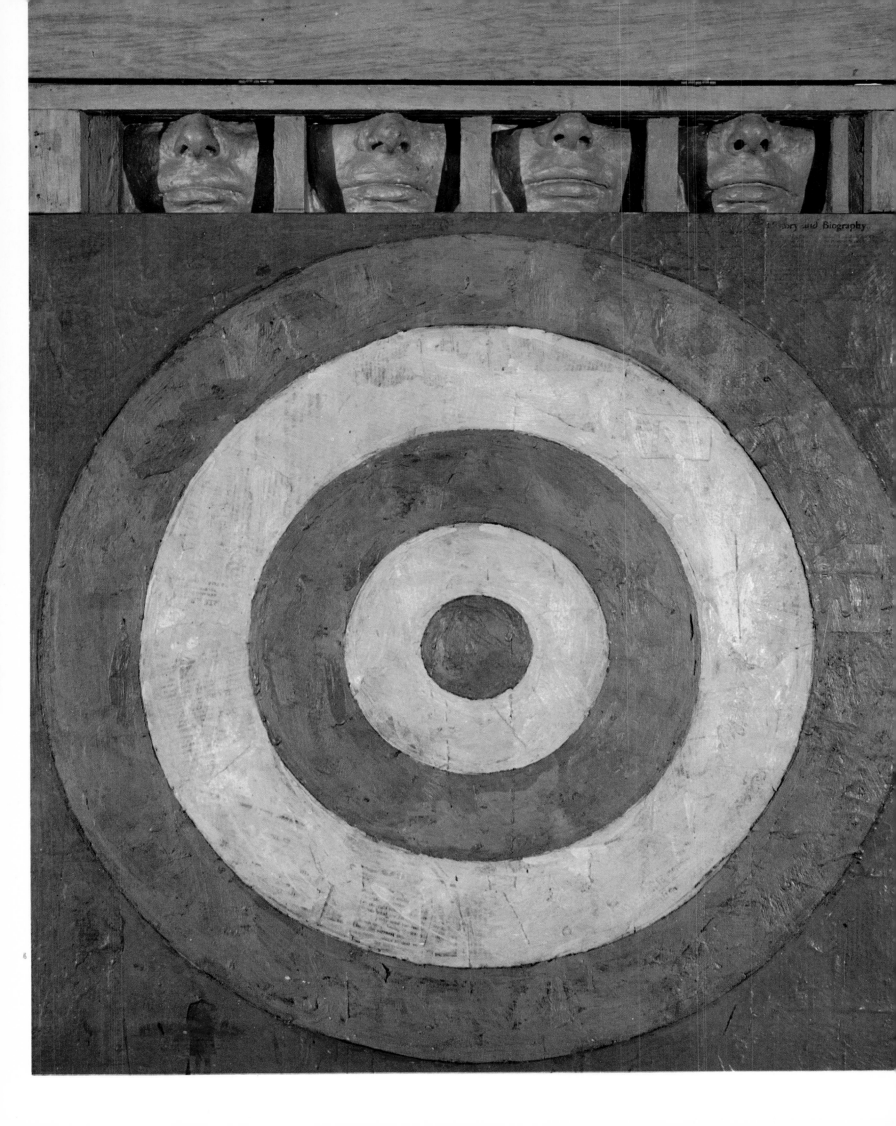

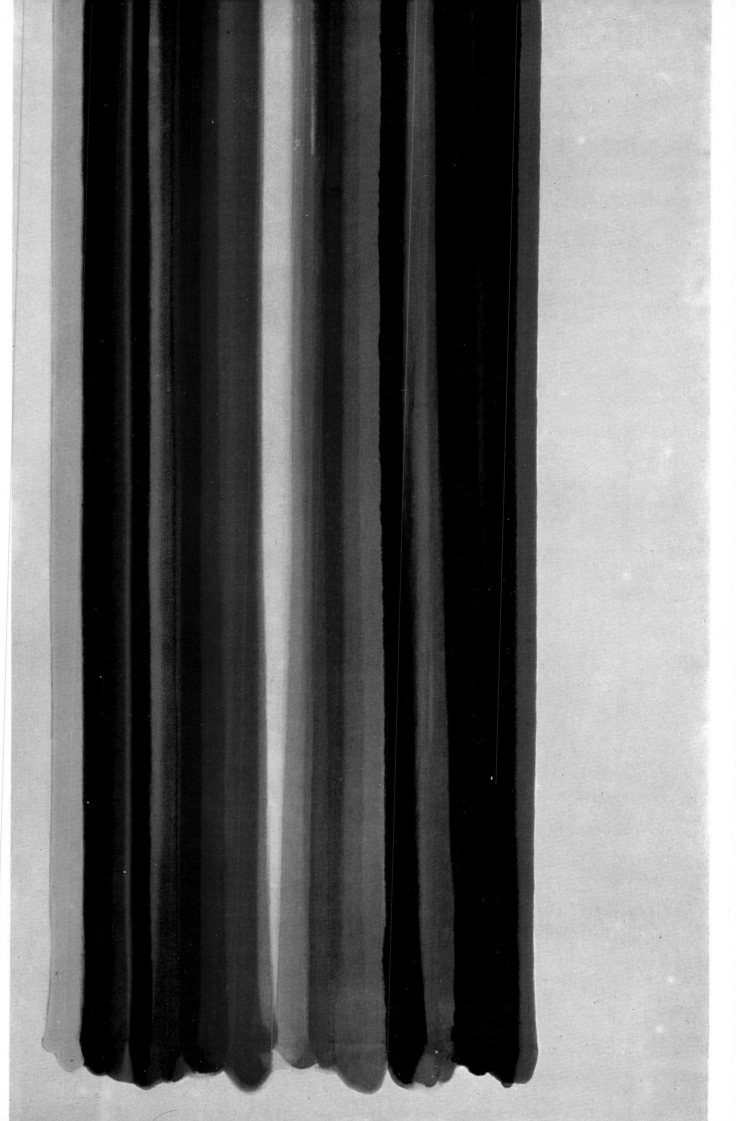

LEFT **Johns:** *White Target with Four Faces,* 75·5 × 132cm, 1957

RIGHT **Morris Louis:** *Third Element,* 218 × 130cm

Latham: *Film Star*, 160 × 198 × 25cm, 1960

John Latham's work is the prime example of radical social concern in art. His avowed intention is to use art in order to change the world and to develop a new language and conceptual basis for discussing and processing it. He wants to deal what he recognizes as a divorce between the intellect and emotions. His work is concerned with an analysis of what an art work *is* and what use society makes of it. He is a constructive iconoclast, wishing to disturb a complacent public and destroy meaningless institutions and shibboleths. His most notorious act was chewing and fermenting a copy of Clement Greenburg's *Art and Culture*, which he then returned to its owner, the library of St. Martins School of Art, as a protest against the awe and reverence in which it was held. His work has isolated him from the art world establishment — though he had a Tate Gallery show in 1976. His work is neither susceptible to conventional display nor to sale. As a means of developing ways of being of use to society he founded the Artists' Placement Group in 1966. The intention of the group was that artists should apply their expertise and particular insights in industrial organizations to the mutual benefit of art and industry.

of new media or new methods of exposition, opposed the apostles of the new-figuration. Neither side seemed much in favour of artistic pluralism. The figuratives who had enjoyed a long run of conventional success seemed to dislike nothing so much as the ascendancy of the new critical establishment. The old establishment, meanwhile, organized a strange hybrid exhibition of British Painting at the Royal Academy, London, in the Summer of 1977 which was little more than a vast roll call of British *painters* of the previous decade. This was seen by one critic (recognizing the significance of many strange bedfellows) as a huddling together for warmth in the face of the cold blast of indifference and apathy that their work had engendered, not only among the newly dominant critical clique, but the public at large.

Peter Fuller claimed that the 1970s would 'be seen retrospectively, as a time when the visual arts as practised by professional fine artists were reduced to residual forms of little cultural or social significance'. Mainly his criticism was directed at painting; of all the painters under the age of thirty-five with whose work he was familiar, he could make out a case for supporting possibly only one. His objection was that painting had become both the content and the subject matter of the work, and that this was true of realist and formalist painters alike. He felt that painting had declined into a type of debased craft activity no longer capable of being modern, for not only had it lost its impetus, but its nerve also. Consequently painting has been super-

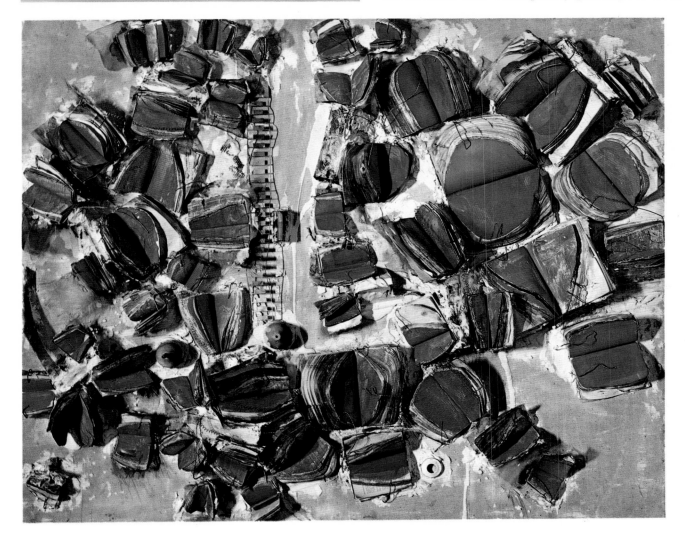

OPPOSITE **Kline:** *Dalia*, 208·3 × 170·2cm, 1959

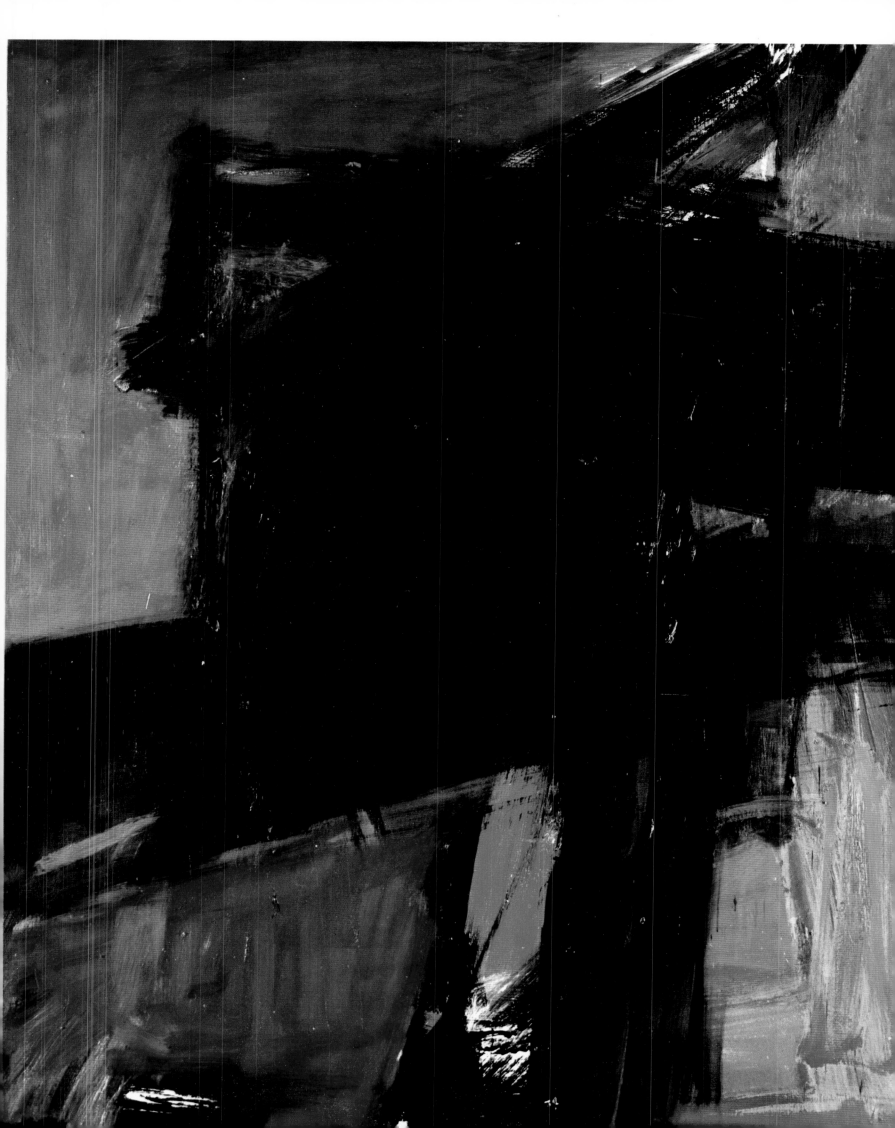

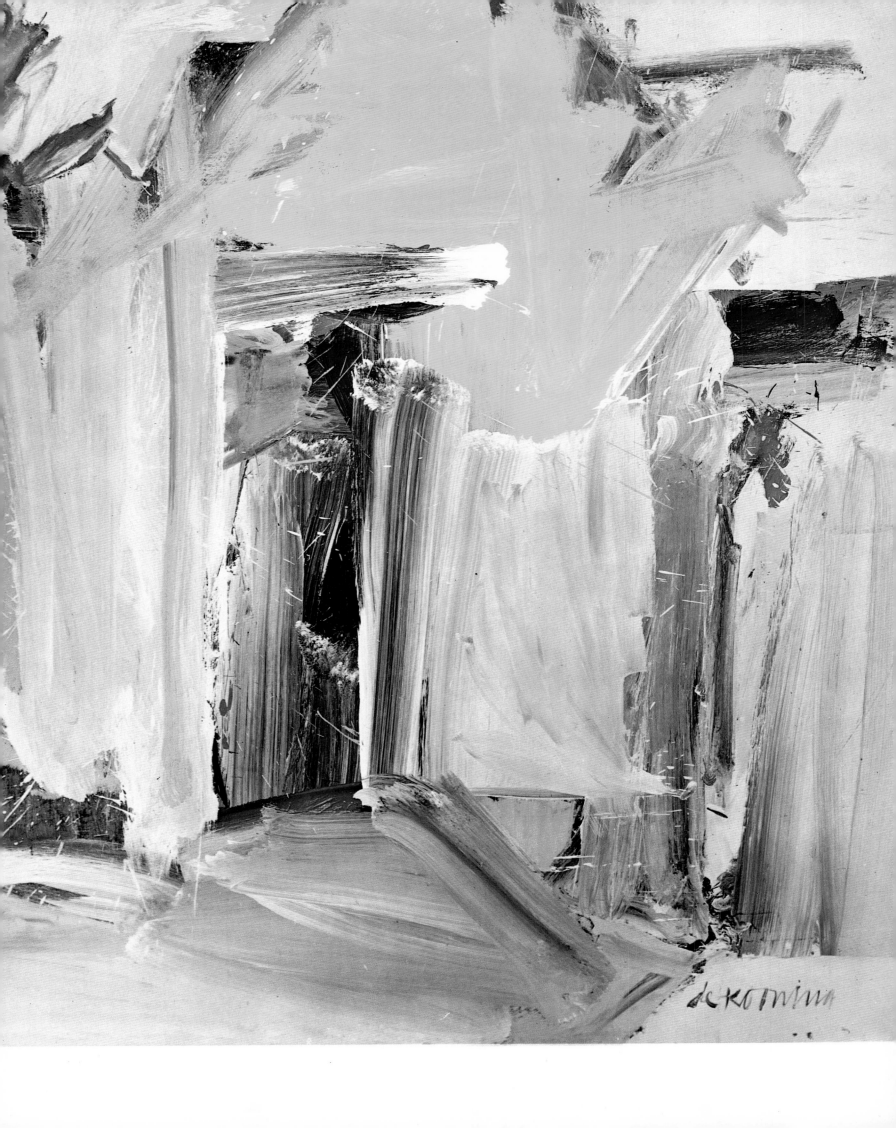

de Kooning: *Door to the River*, 203·2 × 177·8cm, 1960

seded by what were previously only fringe areas of expression but which have latterly come to occupy the centre of the stage.

Increasingly artists have come to believe that their future lies in creative *acts* rather than in merely rearranging and examining past phenomena and trends in art. Persistently twentieth-century art has thrown up practices which have resisted conventional categorization, and it has long been an established platform of artists since Duchamp that they wished to resist the annihilation of immediacy and cultural dynamism that fixing, analysing and naming involved. They felt that, in conspiring in such activities, they were relegating fresh and cultural compelling work to ineffectiveness by placing it in the mausoleum of art history. In his introduction to *Art in the Age of Risk* Gregory Battcock wrote that 'art *is* revolution'. He thought the fact that art, especially modern art, is never establishment was taken too much for granted. He felt that it could be both academic and establishment, but that much modern art was for art historians.

This is emphasized by the recent tendency for the distinction between museum (as a repository for finished art) and the gallery (as a venue for modern art, and by extension, that it still has contemporary social and cultural relevance)

Dubuffet: *Business Prospers*, 165 × 220cm, 1961

Dubuffet is one of the enigmas of contemporary art. His work, invariably lyrical and deliberately childlike, is the product of a painter whose self-confessed aim has been to 'replace Western art with that of the jungle, the lavatory, the mental institution – l'art brut'. His polemics of cultural insurrection, *Anticultural Positions* and *Asphyxiating Culture*, are manifestoes in favour of aesthetic subversion. Despite the fact that Dubuffet's art aspires to that of the child and the primitive it exists well within the boundaries of the long-established modernist tradition. For all his anarcho-revolutionary zeal it is a fact that Dubuffet has not been innovative: Harold Rosenberg has pointed out that by the time Dubuffet entered the art world all those moves on which his reputation now rests had been made: 'It is precisely in appropriating the fruits of old revolts that he represents revolt in the museum. The aesthetic subversion that ended with World War II lives on in Dubuffet as revolutionary pantomime.'

to become blurred. As museums have increased their role as shapers of a culture and have demonstrated their avant gardism through the provision of facilities for the display of experimental work, power has become concentrated in too few hands, and the wrong sort of hands. It has denied the artist the possibility of genuine creative rebellion for fear of compromising those people who would ultimately have to consecrate his cultural success by including work in their permanent collections. Above all the artist has wished to avoid presenting the new viewer with blinkers and preconceptions, and this may account for the mutual antipathy between living artist and art historian. The artist Lillian Lijn once said, 'One can be quite sure that an art historian will *never* get the point'.

There has also been another rejection — that of the critic by the artist. In the past, both recognized that they were dependent on each other. The artist valued the critic as an interpretor, but this is no longer true. Many artists who have rejected painting have dismissed the critic, because they feel that the relationship of the spectator, the work, and the artist is such a sensitive one that the intervention of the interpreter/critic upsets a delicate balance; they reject his priestlike role. The irascible Picasso was without peer when it came to being anti-critical. 'Mathematics, trigonometry, chemistry, psychoanalysis, music and whatnot have been applied to Cubism to give it an easier interpretation. All this has been pure literature, not to say nonsense, which brought bad results, blinding people with theories' (1923).

Indiana: *The American Dream*, 183 × 152·7cm, 1961

The fundamental objection to published critical analysis is Heisenberg's Uncertainty Principle — that the very act of measuring or analysing a phenomenon itself distorts the object observed. Artists taking this view — again they are not only those who have abandoned painting for other means of communication — wish to subvert the normal critical role. They believe that the root of many problems lies in the failure of many critics to appreciate the fundamentally dichotomous nature of each artist and the degree to which at present they are subject to almost irreconcilable external pressures. In the past the artist felt free, was encouraged to dissociate himself from the pedestrian concerns of everyday life and to concentrate, on his work whatever it might involve. Now, by what amounts to a process of osmosis — so subtle has it been — the artist is required to make a more direct contribution and to arrange to pursue ideas which will benefit the rest of society in a direct way.

The twentieth century has been a period of frenetic changes of direction for artists — hence the prolificacy of the '-isms' and '-ologies' which litter art history texts. Change, not to be confused with progress, has gained, or seemed to gain, momentum as the century advanced, but this might be the result of the media's determined efforts to unearth new phenomena rather than a consequence of genuine artistic innovation. It may well happen that one of the functions of the artist is to create an atmosphere of change. There is no consensus in favour of the notion that change means an absolute rejection of the modes and materials of the past. We can recognize in the careers of even the greatest twentieth-century masters a return to and reworking of past themes. There may well be new problems, but the answers may be old ones.

Concerning the fate of painting then, Peter Fuller was not so pessimistic as his statement initially suggests for he ultimately anticipated that painting would continue to have a

Rauschenberg: *First Landing Jump*, 225·6 × 182·8cm, 1961

The twin figures of Rauschenberg and Jasper Johns dominate the mid-century. Both rebelled against the hermetic solemnity of Abstract Expressionism — Rauschenberg erased a de Kooning drawing — and, as heirs of the Dada spirit, they succeeded in opening up a whole range of problems concerning the relationship between art and life. It was Rauschenberg who said: 'Painting related to both art and life. Neither can be made — I try to act in the gap between the two.'

Rauschenberg, probably more than any other artist, is responsible for the relegation of painting into a secondary preoccupation for artists. He incorporated non-art junk into his work, and extending the canvas into the room destroyed the distinction between painting and sculpture. Essentially his art was urban, and his assemblages combined the rejected materials of a consumer society. He was not concerned with re-creating an organic whole as much as with opening up avenues of communication between art and every-day reality. His work led artists to abandon their restraint about what constituted an art work. Hence, his collage-assemblage principle became applied in a number of other situations: the visual drama of the Happening owed much to his innovations, as did Pop Art.

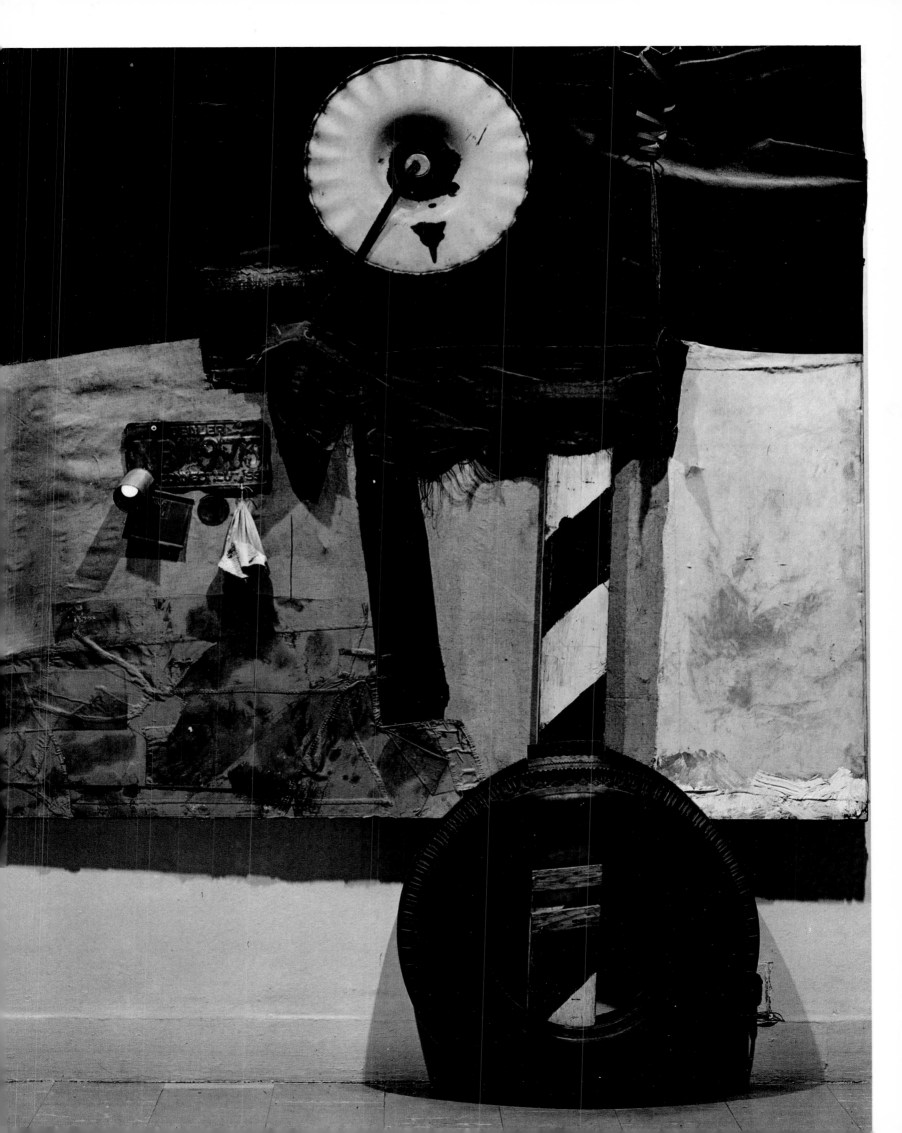

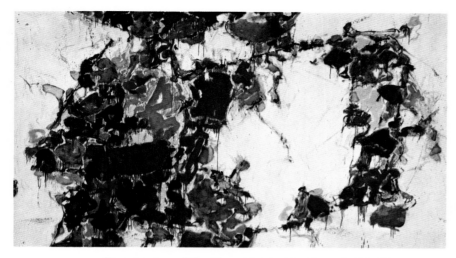

Francis: *Around the Blues*, 137·2 × 487·6cm, 1957–62

role, even if it was one that most painters and commentators might not favour. He dismissed the claims of realists and formalists alike.

> I do not believe that there are any grounds whatever for investing hope in the possibility of a 'realist' revival if by 'realist' one means, depicted in the manner of those outmoded representational conventions through which a particular class trained its professional artists to depict the world itself while declaring those conventions to be synonymous with the truth.

Fuller rejected Photorealism, Hyper-realism and related tendencies, but of all the current attempts to reinstate the relevance of painting, he saw 'Social Realism' as the threat to be opposed most vigorously. It represented for him no more than the harnessing of the passé pictorial conventions of the bourgeoisie to express the historical experience of another class. 'A realism' he wrote 'which does not refer to *historical becoming* is an anachronism; a realism which does not affirm that things can be other than the way they are is a lie; and realism which mistakes superseded representational conventions for the truth is reactionary'. Fuller was ultimately optimistic about the continued role that painting might have. Its future he felt lay in 'a realism which attempts to take its standard from the future that is I believe, the only possible way through for the medium'.

In examining those developments in various areas of human endeavour which represented the birth of the modern age during the period, 1890–1914, we soon realize that the visual arts stand out as one of the principal forcing grounds for modernism. In studying subsequent developments in art we are forced to return to that period in which the roots of many subsequent innovations lie. Certain major themes and debates emerged at that time, and conflicts became apparent which have continued to be sources of interest and discussion. These preoccupations are what have given twentieth-century art its peculiar character: many of them were introduced into art from other areas of activity

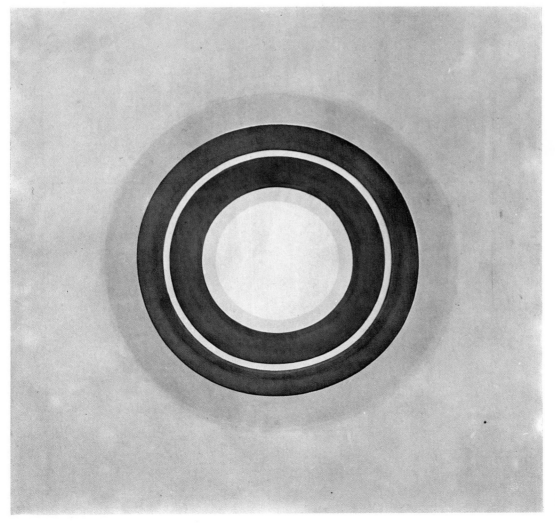

Noland: *Winter Sun*,
177·5 × 177cm, 1962

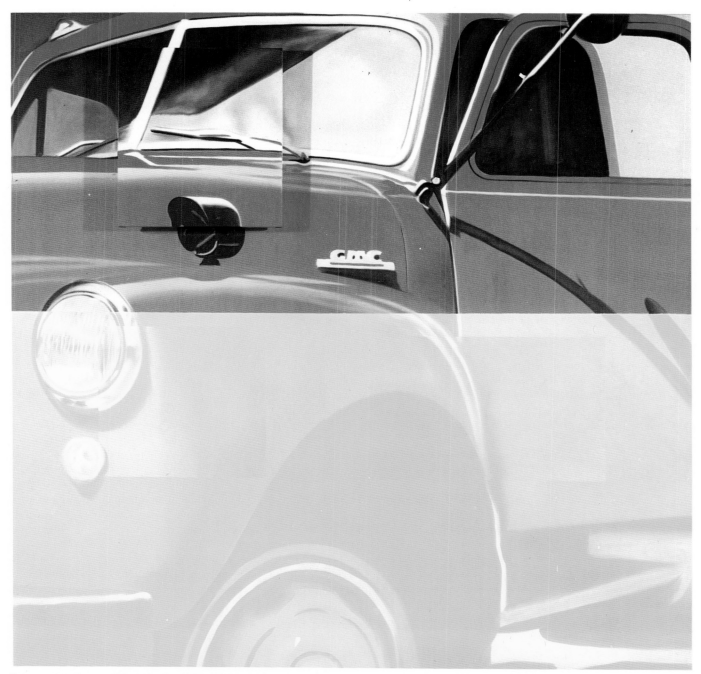

Rosenquist: *Broom Street Truck*, 182·9 × 182·9cm, 1963

Reinhardt: *Abstract Painting*, 152 × 152cm, 1960–2

Reinhardt, determinedly a painter, was the keeper of the American art-conscience during the sixties, fulminating against the 'chi-chi junk' and what he saw as other mindless excesses being produced. He is best known for his latest paintings which are epics of modernist-purist Post-Painterly Abstraction. He made his reputation during the nineteen-fifties when, after his brief period of calligraphic work reminiscent of Tobey, his images became large blocks of colour covering the whole picture surface. At that time his work was not dissimilar to that of his friend Rothko. Later, from the arrangement and orchestration of colour shifts, he moved towards blackness — late paintings being so dark, and their colours so close in value, as to give the superficial appearance of being black. The form of these paintings is usually the same — a cross shape within a square. Reinhardt's precursors are the painters of the De Stijl group, but he was far more lyrical. Later, in his determination to produce a pure exploration of aesthetic doctrine, he got rid of all extraneous elements even the shimmering Rothko-like movement.

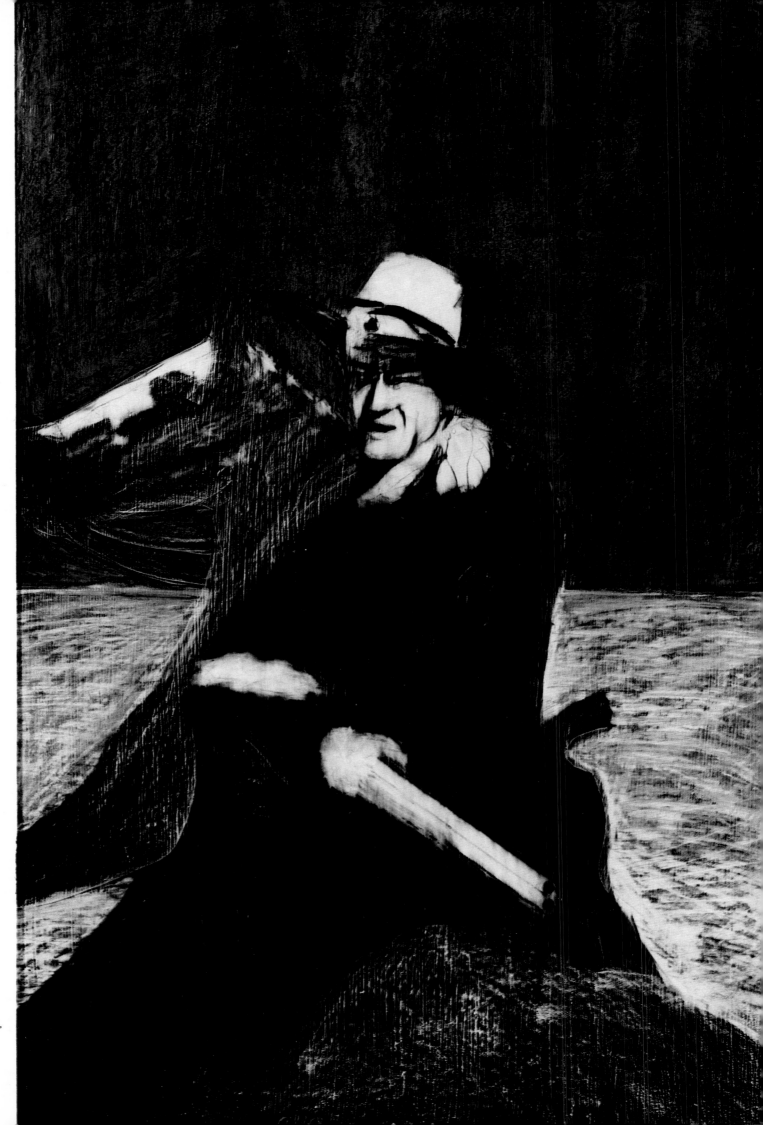

Gill: *John Wayne Diptych,* 121·9 × 157·5cm, 1963

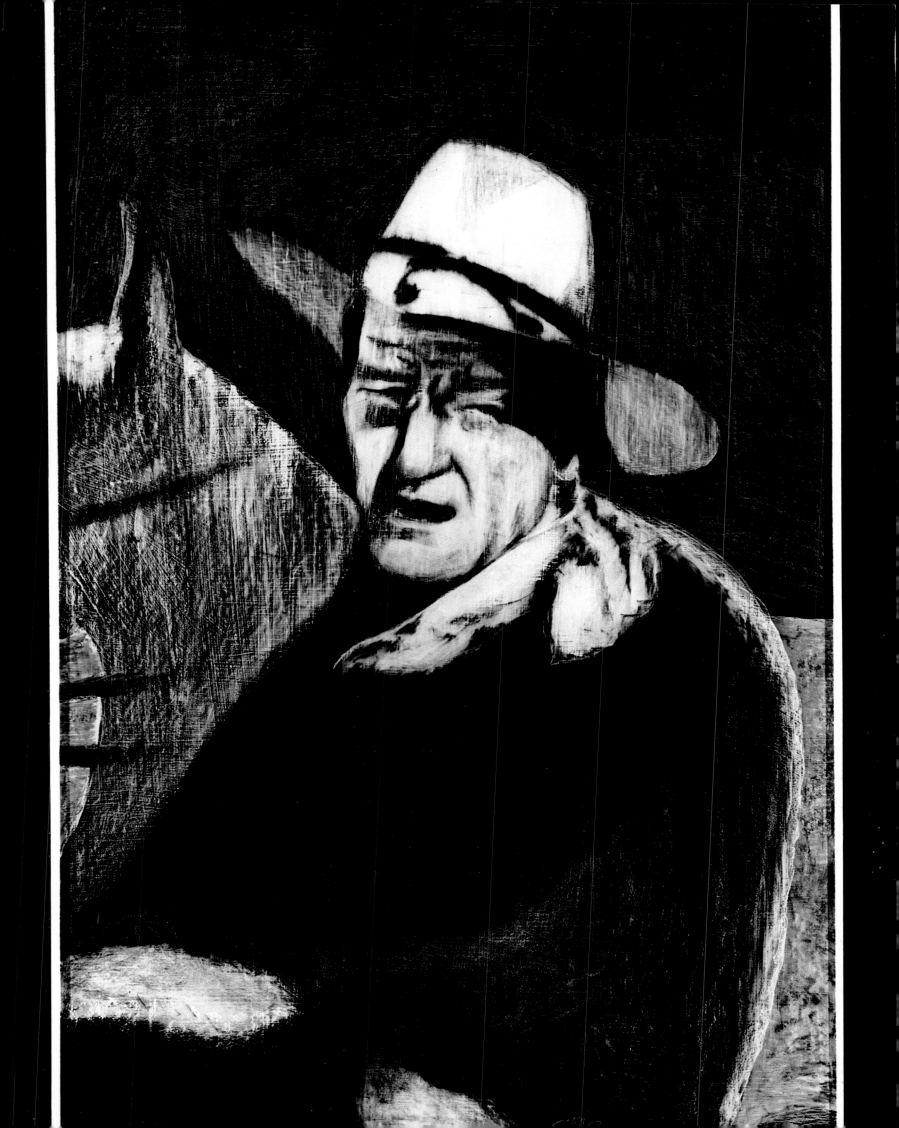

at that time. Some of them have always concerned artists, but on every occasion they were treated with a different emphasis.

Of these major themes the Surrealist, Constructivist and Expressionist impulses predominate. On the one hand, Expressionism's subjective evocation of sensations, through the use of forms and colours which grew out of symbolism,

Anuskiewicz: *Solution and Separation,* 91·4 × 121·9cm

Anuskiewicz is an heir of two separate traditions: on the one hand, the rigorously objective style of Joseph Albers' disciplined colour explorations in the *Hommage to the Square* series (which he made by placing immaculate flat squares of colour, one within another); on the other hand, the more carnival style of Victor Vasarely, in which surface elements of design are activated kinetically to create spatial illusion. In his exhibition 'The Responsive Eye' (1962) William C. Seitz showed works whose theme was perceptual abstraction or 'Optical Art'; that is art whose only association with the natural world concerned the dynamics of retinal stimulation. Anuskiewicz is a puritan even among Op painters, for not only does he eschew the expressionistic romanticism of the colour imagists, such as Morris Louis and Kenneth Noland, but also the monochrome frivolities of Morellet and Bridget Riley. Like Albers, he is a severe single minded explorer of pure geometric shape — usually that of the square.

Hartung: *T 1963 − R 40,* 180 × 142cm, 1963

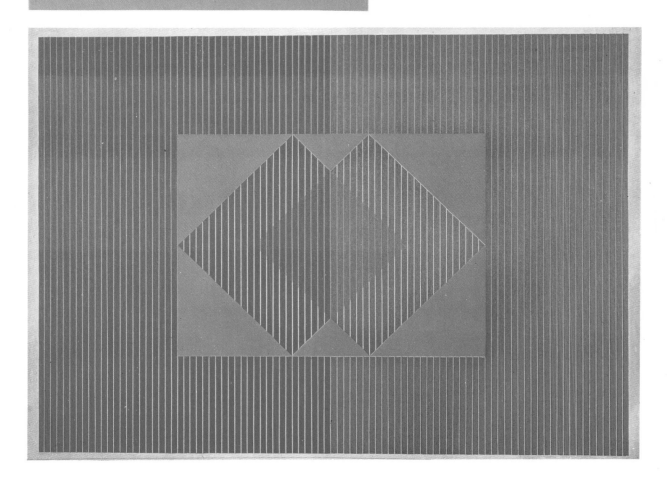

Pasmore: *Black Abstract,* $152 \cdot 4 \times 152 \cdot 4 \times 1 \cdot 3$cm, 1963

laid the foundations of the movement towards abstraction and, on the other hand, the rational, empirical, scientific approach inherent in Constructivism, are the two poles between which twentieth-century art swings. But the Surrealist impulse had its roots in Dada, not, strictly speaking, an art movement at all, as much as a new ethic — anti-war, unconventional, anti-bourgeois, anti-bureaucratic — which vacillated between negating art through ridicule and yet introducing new forms and materials into it at the same time. Surrealism was an art of impulse rather than rules, and it inherited its irrational aspects from the Dadaist games. The main emphasis was on a liberating of the spirit through

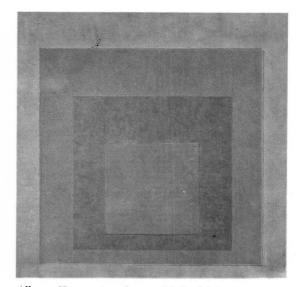

Albers: *Homage to a Square*, 91·5 × 91·5cm

Lichtenstein: *Brush Stroke with Splatters*, 172·7 × 203·2cm, 1964

Lichtenstein is best known for the paintings of comic-book blow ups which he did in the sixties; indeed, his name is virtually synonymous with Pop Art. It would be a mistake to suppose that he simply lifted these images from popular culture, from advertisements and comics, and simply represented them on a different scale. As this illustration indicates there is in his work process a great deal of personal intervention, because he is as concerned with formal problems as his predecessors were. The incorporation of vulgar materials into art was not new. Duchamp, Picasso and later Rauschenburg had created precedents. In introducing these materials Lichtenstein extended Rauschenburg's attempt to work in the gap between art and life in another direction — to break down the barrier between so-called 'high' and 'low' art. His treatment of his chosen themes is bland; in his pastiches of high art or of the banal it is difficult to determine whether he elevates, denigrates or celebrates his source material. In a sense that does not matter, for what he skilfully does is to explore an aspect, that is peculiar to modern taste, and is concerned with the mechanics of image reproduction, and the values we attach to it. In so doing he subverts commercial and artistic conventions alike with deadly good humour.

the free play of the imagination. All three tendencies had political roots, all of them recur: they are as it were three spines forming the framework of modern art. At certain times one of them becomes ascendent, only to fade as the attention of artists moves elsewhere.

It is easy to be deluded into thinking of these things as

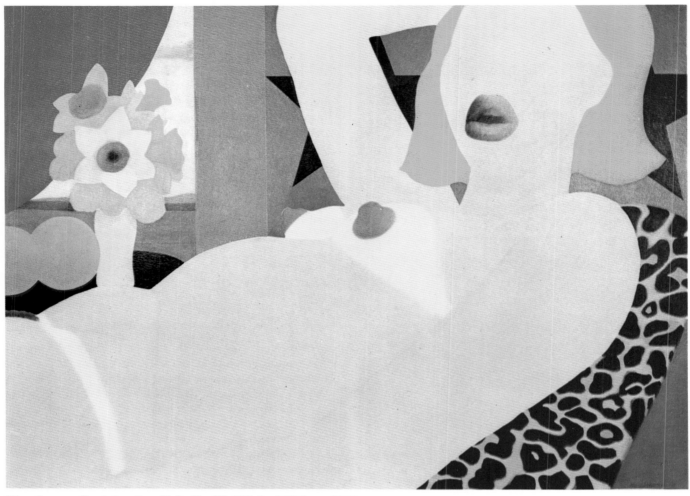

Wesselmann: *Great American Nude, No. 57*, 121·9 × 165·1cm, 1964

only taking place 'within' art, into thinking of it as an hermetic activity, divorced from societal changes. When we speak of the development of a style of painting during a particular period it is important to remember that it is likely to correspond with stylistic changes in other art forms. There is likely, despite Picasso's strictures about saying so, to be an affinity with changes in other fields. In the past, develop-

ments in natural and physical sciences, philosophy, psychology, engineering and architecture have mirrored, or even conditioned, the iconography, methods and materials of art. These coincidences may be the result of technological

Ellsworth Kelly: *Green, Blue, Red*, 185·4 × 254cm, 1964

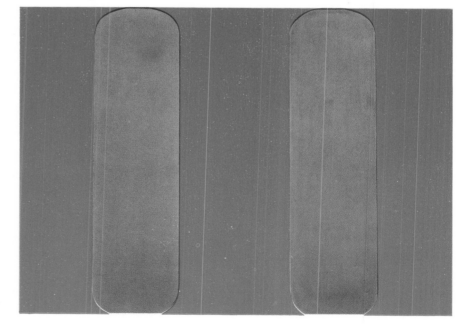

Noland: *Prune*, 169 × 169cm

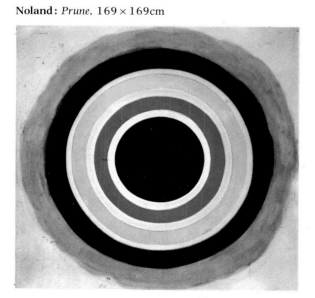

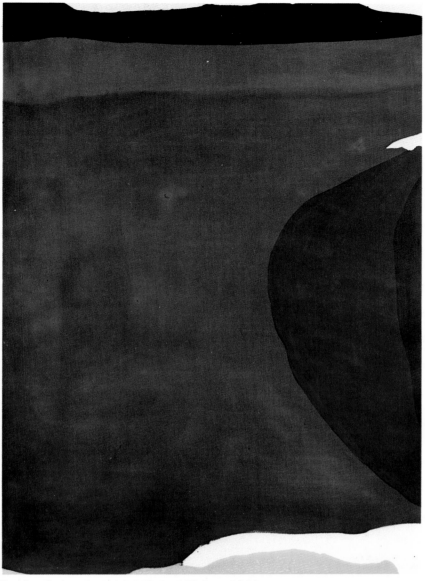

Frankenthaler: *Santorini*, 269·2 × 175·3cm, 1966

innovations making a simultaneous impact, or be occasioned by artists in different media reacting to novelties in their environment, but, often, the explanation is not so simple. Such coincidences are not susceptible to any one convincing explanation. Take as an example those cases of periodic huge leaps forward in which man achieves simultaneous enlightenment across the whole spectrum of his activities. In his radio lecture 'The Double Image' Professor Alan Bullock catalogued changes in society between 1870 and 1913

> Anyone who wants to understand the origins of 20th century art or science has to go back to these years. And the origins are represented, in many cases, not by a modest inching forward, but by a bold leap — the originality of which is not diminished when later generations take up and develop the possibilities further. . . . Certainly it is possible to see a common temperament at work, radical, innovatory, experimental — but continuing so, not settling down with any grand certainties or remaining content with the achievement of one set of new forms, or a common language of expression. The old patterns have been broken up: this time they were not replaced.

There has been no definitive study of this phenomenon. The nearest indicator of what causes this leap is provided by James Watson's description of his and Crick's discovery of the molecular structure of D.N.A., which is vivid illustration of the correspondence between the intuitive approach of the artist and the similarly brilliant guess on the scientist's part. It indicates that scientists and technologists are not simply intellectual machines, but that chance and aesthetic factors figure in their deliberations. Koestler, after all, claimed that scientists were concerned with the beauty of their molecular structures and the elegance of their equations.

Rivers: *Lions at the Dreyfus Foundation, III*, 105·4 × 199·4cm, 1964

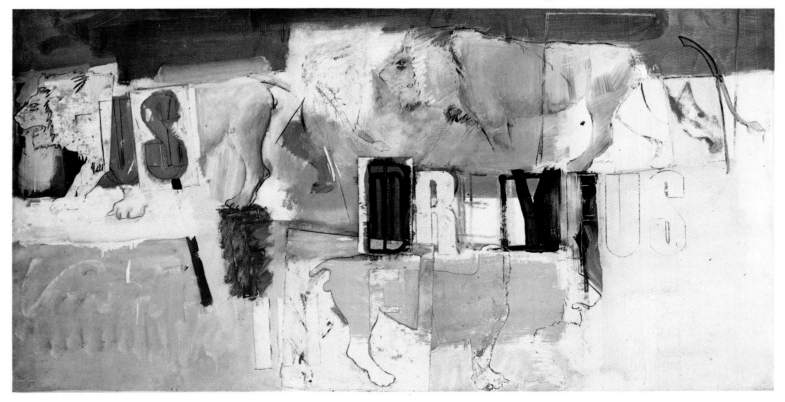

Superficially, it seems that great movements in science are accompanied by great movements in art. This may be simply that our organization and expression of knowledge whether artistic, scientific or natural, are expressed in similar structures. It is the actual movement of decision that is a puzzle. Cross-fertilization between art and science is far from symbiotic. There is evidence of a considerable debt owed to science and technology by artists — the development of the machine aesthetic was a conscious commitment by Vorticists and Futurists, long after the mechanized society had become a fact. But it is also a fact that earlier, in art and science alike, there had been a joint proclamation of the bankruptcy of traditional reason and its wholesale replacement by new, if impermanent models. As ideas of the laws governing the physical world were overthrown, so the Cubists reconstructed painting, supplanting the mundane depiction of the superficial appearance of the physical world with formal laws of the intellect. From that time on, the course of twentieth-century painting was set: the artist had committed himself to a constant process of rejection and renewal, he could no longer rely on the absolute certainties of a received visual language. Visual art entered a state of

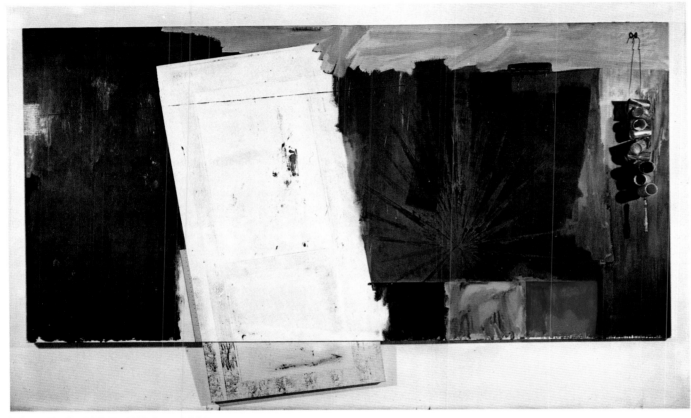

Johns: *Studio*, 186·7 × 369·6cm, 1964

Motherwell: *Open 26*, 232·4 × 330·2cm, 1968

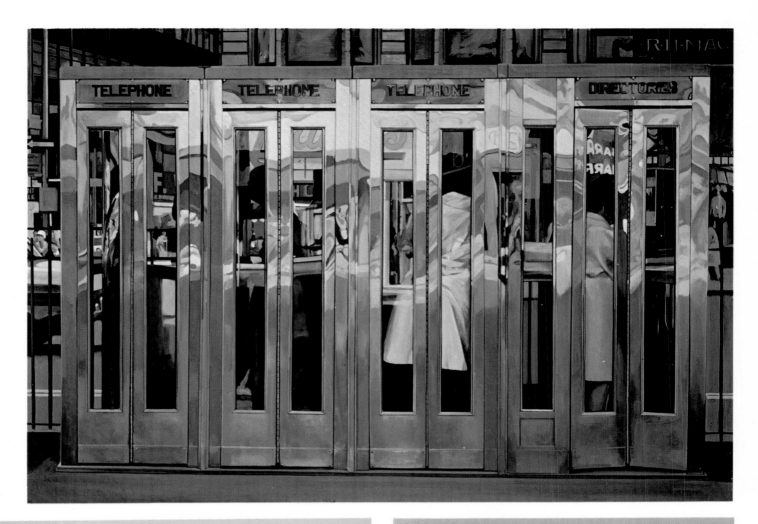

Estes: *Booths*, 122 × 244cm, 1967

Estes has been accepted as a Hyper-, Photo-, New- or Super-Realist (the names are interchangeable), that is a painter who faithfully records and transmits every details of the subject observed. It is not an accurate description in his case for, just as an artist like Lichtenstein selected from his source of comic-book imagery only what he wanted, so Estes considerably edits what the camera records. He works in a conventional painterly way, arranging his paintings according to traditional canons. And they *are* paintings: the original photograph is the 'sketch', and any subsequent photographic blow-up he would consider too blurred for his purposes. On examination, his works prove to be richly painted — the paint being applied with great suavity. His theory that 'more is less: The more you show the way things look the less you show how they are' is not one that the viewer of his work immediately understands. The smooth Art Deco brilliance of the paintings belies the cluttered tatty urban American streetscape that is his subject matter. Estes' comment lies in the creation of an anaesthetized sterile world — his comment *is* his deadpan presentation of the banalities of the common scene.

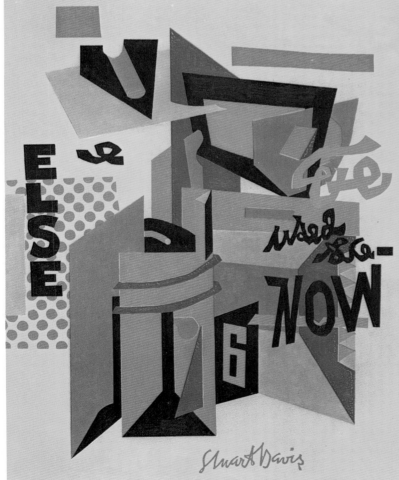

Davis: *Owh! in San Paó*, 132·7 × 107cm

flux, with the artists' exploration of the world, whether it took the form of sensuous intuitive response or ordered objective analysis, by being a consistent procession of challenges and new departures. In this it mirrors modern society with its great uncertainties — a compound of the cataclysmic catastrophes of successive wars and the frenetic atmosphere of a consumer society. All are changes engendered by a society dedicated to the notion of scientific and technological progress, which is another concept that is now being challenged.

Vasarely: *Geminorum*, 195 × 130cm

Vasarely's is a simple art which, because of its super-ficial attraction, arouses much less ire than that of other artists who are in more austere ways doing essentially the same thing. As early as the 1940s he began a rigid programme of pictorial explorations, much in the manner of Albers, of permutations of colour and geometrical modules. These he animated in an extremely disciplined way, investigating ambiguities caused by the colour superimposition of harmonious and dissonant elements. The obsession with move-ment is one of the dominant themes of twentieth-century art. Usually the artist is diverted by convinc-ingly having to render movement in recognizable, representational elements, but in Op Art – or, more properly, Non-objective Perceptual Art – kinetic move-ment remains retinal, arising from sensual experience occasioned by arrangements of colours and lines on a canvas. Its successor was Kinetic Art, in which elements of a composition actually moved, and its roots lay in the experiments of Duchamp, such as the rotating discs and *The Nude Descending*, and in the attempts at developing a machine aesthetic by the Russian Constructivists and Italian Futurists.

Wirsum: *Screamin' J. Hawkins*, 121·9 × 91·4cm, 1967

It would be difficult to discover a painting more sug-gestive of the spirit of the mind-bending, seemingly drug-induced, psychedelia of the 1960s than this one. It is typical of a whole school of American painting which flourished briefly, particularly on the West Coast, of which the titles of the works, such as Sterg-meyer's *The Fluorescent Dancer Enters the Temple of the Golden Scull* (1967) and Nutt's *Miss E. Knows* (1967) are as bizarre as their appearance. It has super-ficial affinities with the work of a number of main-stream artists whose work is affected by both mysti-cism and music, notably those of the Scottish artist Alan Davie, whose painting is also influenced by archaic primitive art and Symbolism. It would be truer to say that the roots of this work are to be found in popular culture, for the debt that it owes to the artists of those comic-books which flourished at the time such as Robert Crumb's *Zap*, *Mr Natural*, and *Big Ass* and Victor Moscoso's *Zap*, *Yellow Dog*, and *Loop de Loop* is obvious. There is also a sense in which a debt, albeit an unwitting one, is owed to Dada and Surrealism. Although these funky canvases may be of no more than nostalgic or sociological interest for modern tastes, the speed with which they entered public collections is a source of wonder; that too says much about that remarkable euphoric period.

List of Illustrations

Bibliography

BAZIN, GERMAIN: *The Avant-Garde in Painting*, 1969
LUCIE-SMITH, EDWARD: *Modern Art*, 1977
LUCIE-SMITH, EDWARD: *Movements in Art since 1945*, 1969
READ, HERBERT: *Concise History of Painting*, rev. 1974
ROSE, BARBARA: *American Art since 1900*, 1967
ROSENBURG, HAROLD: *The Anxious Object – Art Today and its Audience*, 1964